ROYAL
BALLET

STEVEN McRAE

DANCER IN THE FAST LANE

PHOTOGRAPHS BY ANDREJ USPENSKI

OBERON BOOKS

LONDON

WWW.OBERONBOOKS.COM

First published in 2014
by Oberon Books Ltd
521 Caledonian Road, London N7 9RH
Tel: +44 (0) 20 7607 3637
Fax: +44 (0) 20 7607 3629
e-mail: info@oberonbooks.com
www.oberonbooks.com

Introduction © Steven McRae, 2014

Photographs by Andrej Uspenski
© Royal Opera House, 2014

Compilation © Oberon Books Ltd
and Royal Opera House, 2014

A catalogue record for this book is available from the British Library.

PB ISBN: 978-1-78319-088-1
E ISBN: 978-1-78319-587-9

Cover image of Steven McRae in 'Rubies' (*Jewels*)

Cover and book design by James Illman

Printed and bound in India by Replika Press Pvt. Ltd.

Royal Opera House
Covent Garden
London WC2E 9DD
Box Office +44 (0)20 7304 4000
www.roh.org.uk

STEVEN McRAE
Principal

WITH

DON QUIXOTE, 11–27
PRODUCTION ❙ CARLOS ACOSTA

LESLEY COLLIER
Répétiteur

ELIZABETH HARROD
Soloist

IANA SALENKO
Guest Artist

FOOL'S PARADISE, 28–33
CHOREOGRAPHY ❙ CHRISTOPHER WHEELDON

FEDERICO BONELLI
Principal

SARAH LAMB
Principal

'RUBIES' (JEWELS), 34–45
CHOREOGRAPHY ❙ GEORGE BALANCHINE

PATRICIA NEARY
Guest Répétiteur

NATALIA OSIPOVA
Principal

SWEET VIOLETS, 46–51
CHOREOGRAPHY ❙ LIAM SCARLETT

ALINA COJOCARU
Former Principal

JOHAN KOBBORG
Former Principal

EMMA MAGUIRE
Soloist

ROMEO AND JULIET, 52–87
CHOREOGRAPHY ❙ KENNETH MACMILLAN

ALEXANDER CAMPBELL
First Soloist

LESLEY COLLIER
Répétiteur

EVGENIA OBRAZTSOVA
Guest Artist

RHAPSODY, 88–97
CHOREOGRAPHY ❙ FREDERICK ASHTON

ALEXANDER AGADZHANOV
Senior Teacher and Répétiteur to the Principal Artists

ALINA COJOCARU
Former Principal

LESLEY COLLIER
Répétiteur

LA SYLPHIDE, 98–103
PRODUCTION ❙ JOHAN KOBBORG

ALINA COJOCARU
Former Principal

THE SLEEPING BEAUTY, 104–111
PRODUCTION ❙ MONICA MASON, CHRISTOPHER NEWTON

SARAH LAMB
Principal

ROMEO AND JULIET, 112
CURTAIN CALL

INTRODUCTION BY STEVEN McRAE

I grew up around the smell of burning rubber and the thrills of nitro-burning dragsters. The motor sport, drag racing, was my family's life – high adrenaline, high technical efficiency and a life in the fast lane!

In 1993, at the age of seven, I walked into a dance studio on the outskirts of Sydney. Little did I know that my life would change FAST.

How lucky I was to walk into a local dance school that, I can now say, had two of the best teachers you could ever hope to find! I remember my first lesson. It was a jazz class. I still see clearly in my mind the stretching we did, the exercises from the corner, the big jumps. But most of all, it was the day I learnt how to turn.

From day one my teachers unleashed a sense of freedom in me. They made me feel as though anything was possible.

Like most dance students in Australia, I began entering many competitions, and my poor parents basically became my taxi drivers. It was these competitions that, from the age of eight, gave me a chance to use my new-found skills and demonstrate this sense of freedom I had found.

However, in 2002, aged 16, my life suddenly started to accelerate. The Royal Academy of Dance's Genée International Ballet Competition took place in Australia, and I was awarded the Gold Medal. A month later I left Sydney airport en route to Switzerland, where I won the Prix de Lausanne. Little did I know that I was not going to return to Australia. The next day, the Director of The Royal Ballet School, Gailene Stock, asked me to start training at the school. Gailene not only gave me a wonderful opportunity, she propelled me at full throttle into the international dance scene and opened up my world beyond anything I could have ever imagined.

A dancer's career is short-lived and opportunities do not pop up every day; I learnt very quickly to grab each one that came my way and run with it. Here I was on the other side of the world from my home, in London – a city I'd never been to… I'd never even seen a full-length ballet live at this stage! Eighteen months later I graduated, gained a contract with The Royal Ballet and embarked on my career with the Company.

My life in the fast lane as a professional dancer began right from the starting line. My first season with The Royal Ballet ended with me dancing alongside Principal dancers Alina Cojocaru, Johan Kobborg and Federico Bonelli in Frederick Ashton's masterpiece *Symphonic Variations*. Thanks to the Company's Director Monica Mason and Wendy Ellis Somes, who staged the ballet, I was quickly made aware of this treasured piece in The Royal Ballet's repertory. In fact, I had just a few days to prepare due to another dancer's injury.

In 2007, my career started to go up a few gears…

A phone call at midnight from Royal Ballet Principal Roberta Marquez in Paris started a new phase in my career. Roberta was performing *Don Quixote* there, and her partner was injured. She needed a replacement for the following day. I boarded the Eurostar the next morning and discussed the version with her on the phone. I had never performed *Don Q* nor had I ever danced with Roberta. I arrived half an hour before the matinee show commenced: we tried everything once and that was it. We performed and it was the greatest adrenaline rush you could ever imagine.

On my return to London things continued to accelerate.

The following week, due to injury, I stepped in as Romeo alongside the incredible Alina Cojocaru in Kenneth MacMillan's *Romeo and Juliet*. I had five days to learn an entire three-act ballet. *Pas de deux*, solos, sword fights, group scenes with the harlots… EVERYTHING, and all for the opening night. No pressure! It was a moment in my career that was the most exciting yet most surreal. Unfortunately it all flew by so fast.

Just when you thought that was enough high-adrenaline pumping for the moment, there was more to come…

The morning after my *Romeo* debut, I was flown to Tokyo to perform the role of Oberon in Ashton's *The Dream*, again with Alina. It was the quickest 12-hour flight I've been on, since I only had that time to learn the ballet off a DVD that Monica Mason had handed to me when the curtain came down the night before! Waiting for me in Tokyo was Anthony Dowell, former Director of The Royal Ballet, for whom the role of Oberon was created, along with Ballet Master Christopher Carr, both ready to stage the ballet opening in four days' time.

The trust all of these people bestowed on me was truly humbling. The excitement during this period was unbelievable. Surely this was everything I had dreamt of. But going this fast can be dangerous and the risks involved are greater. The pressure of stepping on stage for a full-length ballet with little preparation can sometimes feel like the G-force a racer feels when a car launches off the starting grid, and my body felt it. My career was flying by in the fast lane and then suddenly a parachute was pulled and I came to a crashing halt. My Achilles' tendon was torn and my career was dangling by a thin thread…

Like all motor sports today, when pushing the speed barriers, there has to be an increased focus on safety. This is how I had to learn to approach my career.

My time away from performing – 12 months to be exact – was possibly the hardest yet most rewarding period of my career so far. I watched so many rehearsals and performances and learnt a lot about the profession. My rehabilitation with Pilates instructor Jane Paris and former Royal Ballet Principal dancer Lesley Collier was gruelling. But I felt this was the fresh start I needed and I fell even more in love with my career when away from the stage.

Any fears I had about slowing down quickly vanished. I was suddenly cast with the ballerina Miyako Yoshida and I had the honour of performing alongside her in her Royal Ballet farewell performances of *The Nutcracker*, *Cinderella* and *Romeo and Juliet*.

Dancing with so many beautiful and talented ballerinas has allowed me to grow as a partner and an artist. It has also inspired me to dance in the fast lane. I only had a few days to prepare with some of the ballerinas pictured alongside me in this book. High risk, high adrenaline – just like my father and his racing!

The moment I step on stage is the moment I feel free. The freedom I experienced from my early teachers is something I cherish and search for in every performance. The rehearsal and preparation that goes into these performances can challenge my love of dance. I am not going to lie, some days are simply tough. Your body says 'no', your mind says 'no', yet this burning love of dance forces you to continue pushing to reach new goals. The wonderful image of me rehearsing Ashton's *Rhapsody* with my coaches Lesley Collier and Alexander Agadzhanov sums up this feeling perfectly.

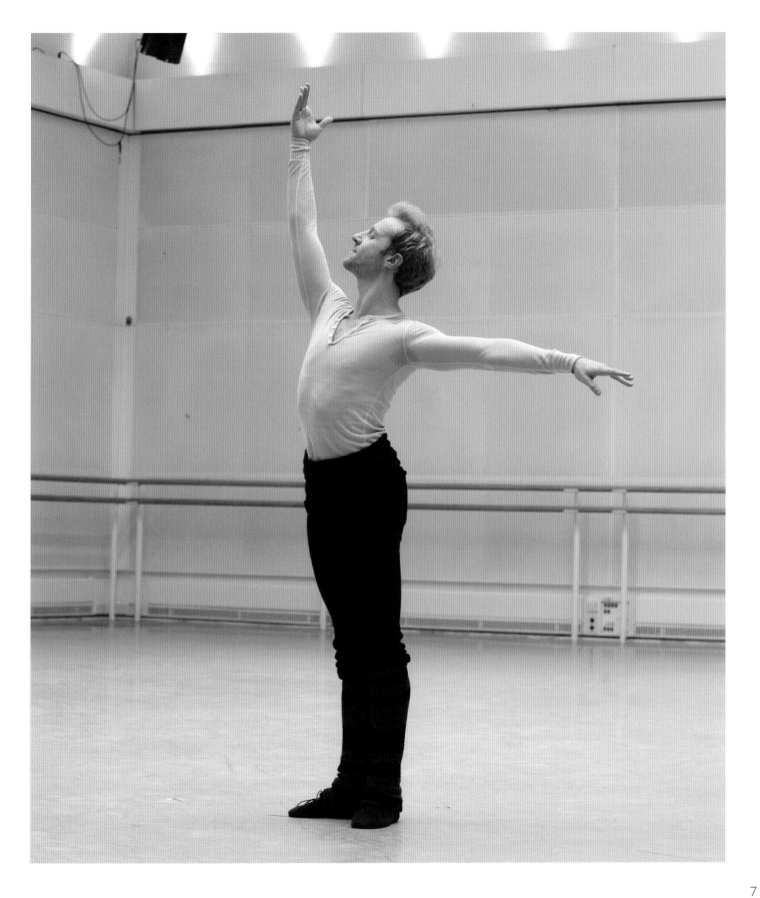

I met Andrej Uspenski in 2004 when I joined The Royal Ballet. He was an instant support and has photographed me regularly since he began taking pictures. He has a talent for capturing a moment that words very often can't explain and is an artist who also captures art. This beautiful book opens a small window on my career over a short period and highlights the Company's vast repertory. Thanks to Kevin O'Hare, the current Director of The Royal Ballet, this past year has truly been a season of highs that I've been fortunate to share with some of the world's greatest ballerinas. It is the diversity of disciplines and roles offered to me by The Royal Ballet that continues to feed my love of dance.

I have to pinch myself looking at each image, since I still can't believe I've experienced all these incredible moments. I see each one as a representation of my development as a dancer and, also, as a person.

A life in the fast lane can be so exciting: it magnifies the pressures and the pains but it highlights the satisfaction one can gain from dedicating your life to your art form. I don't plan on slowing down any time soon… I am only starting to step on the throttle!

Dancer in the Fast Lane

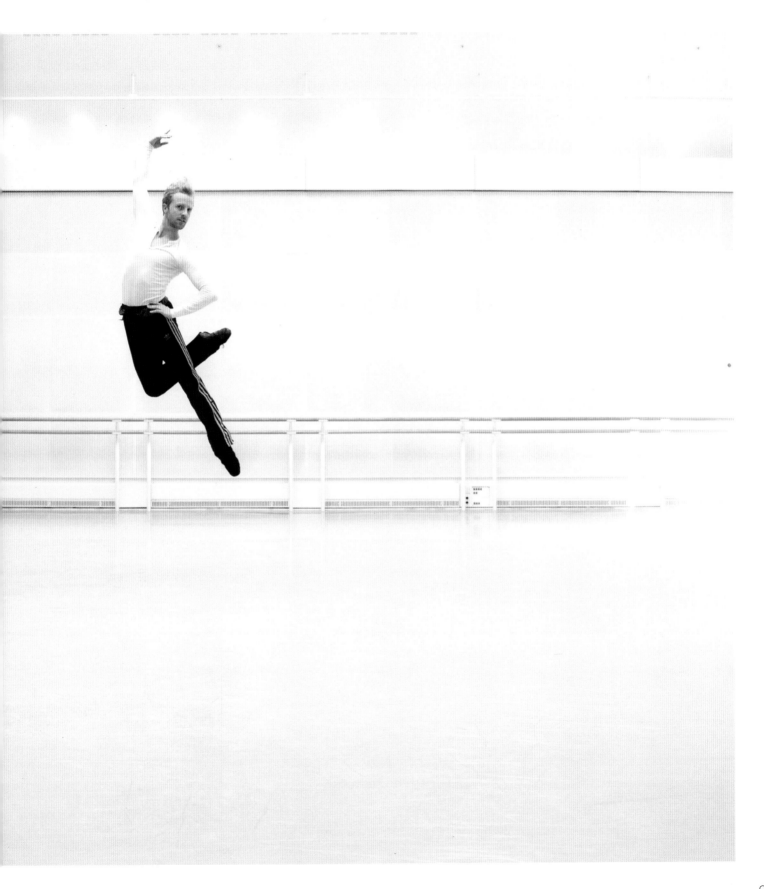

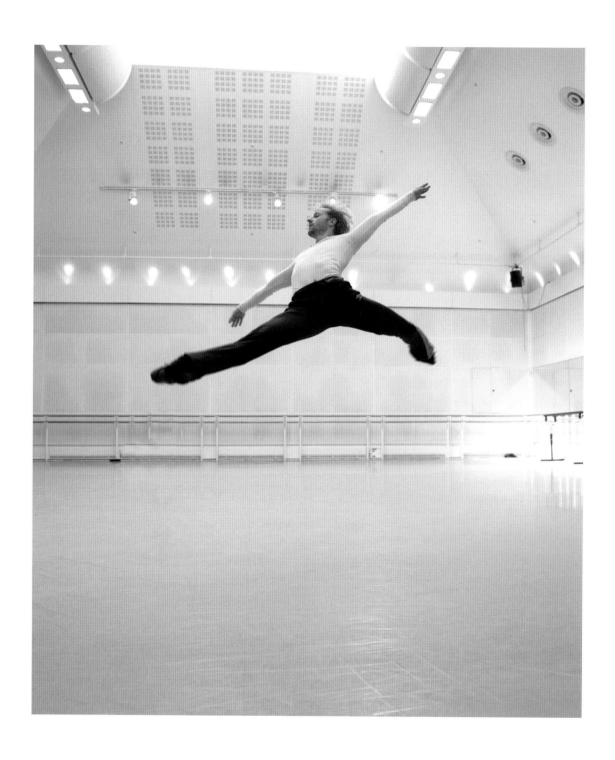

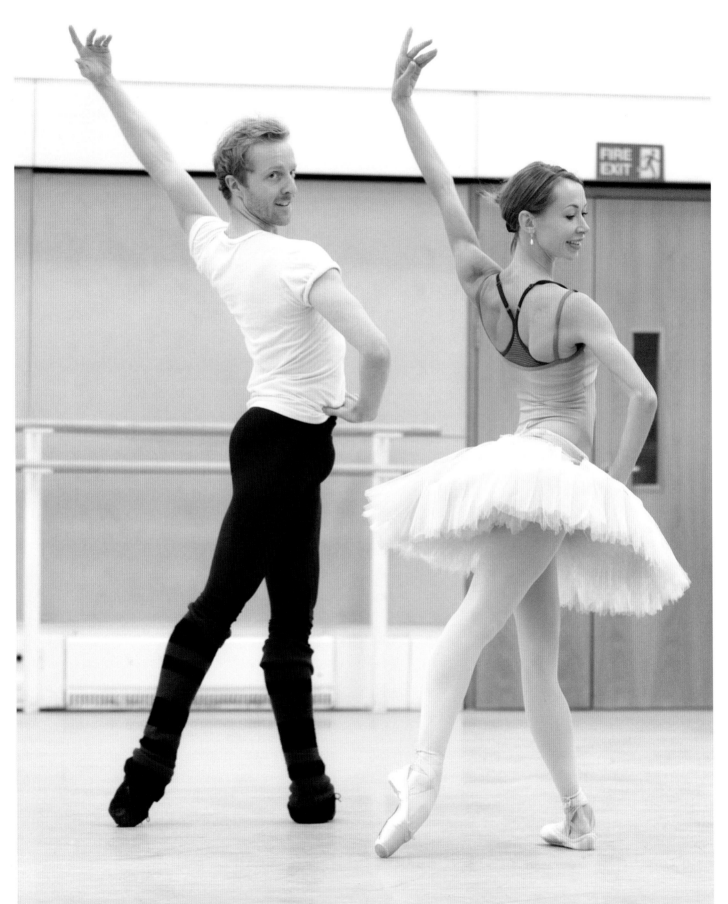

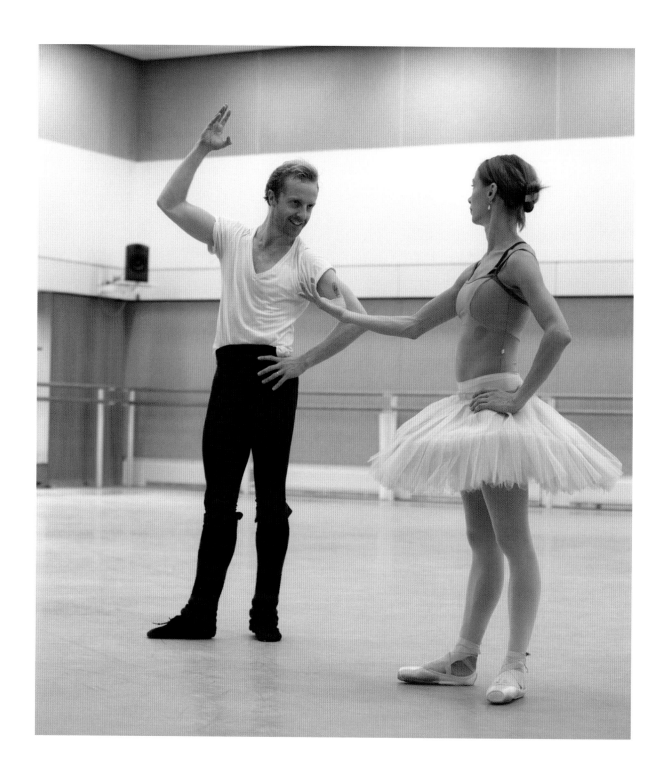

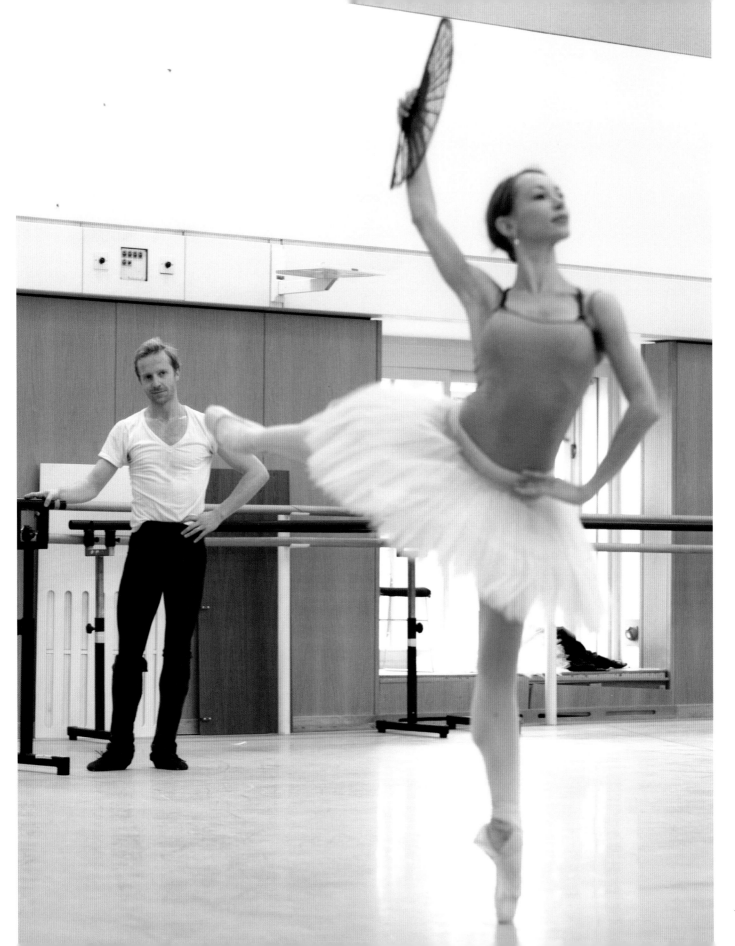

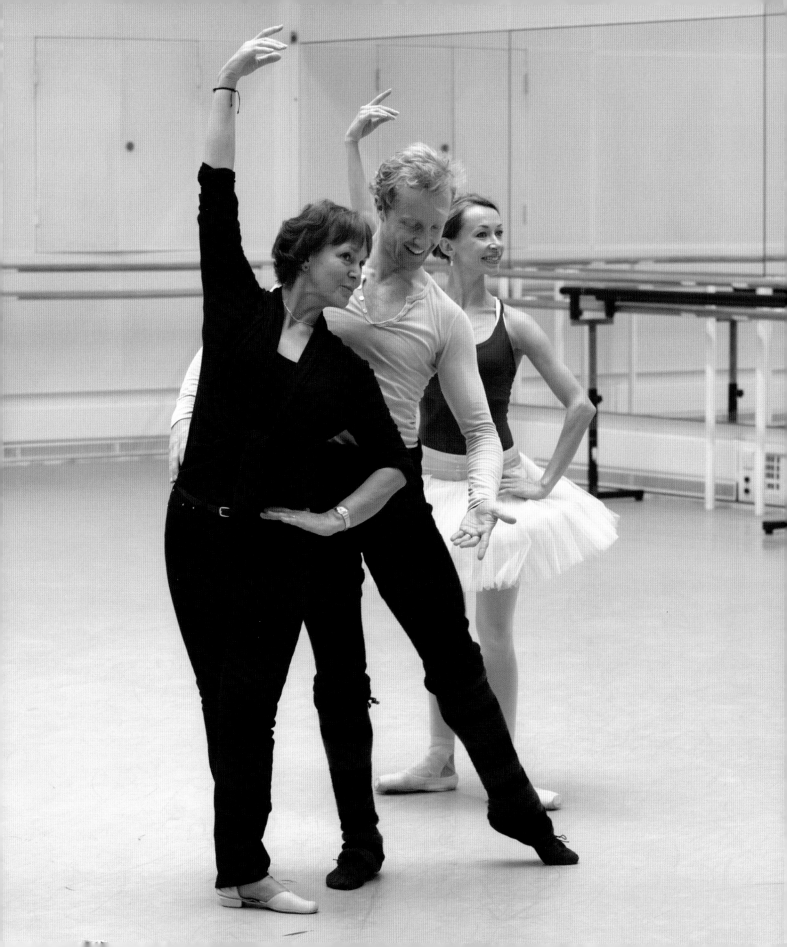

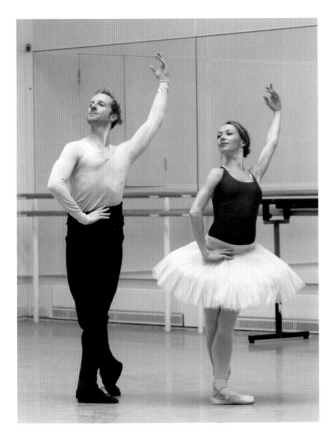 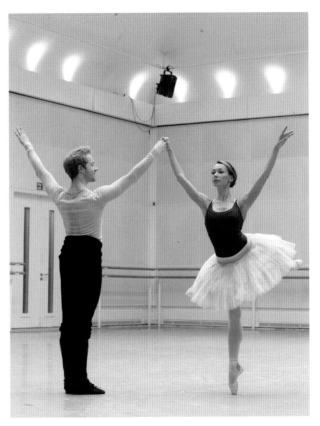

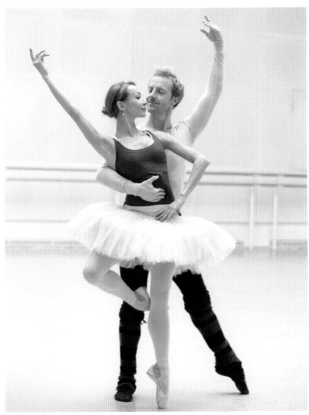 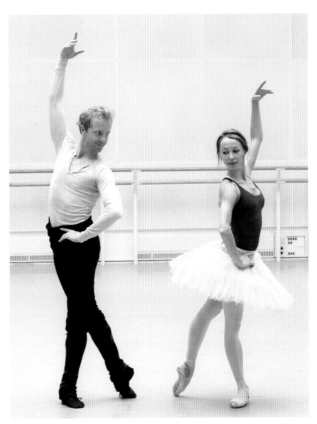

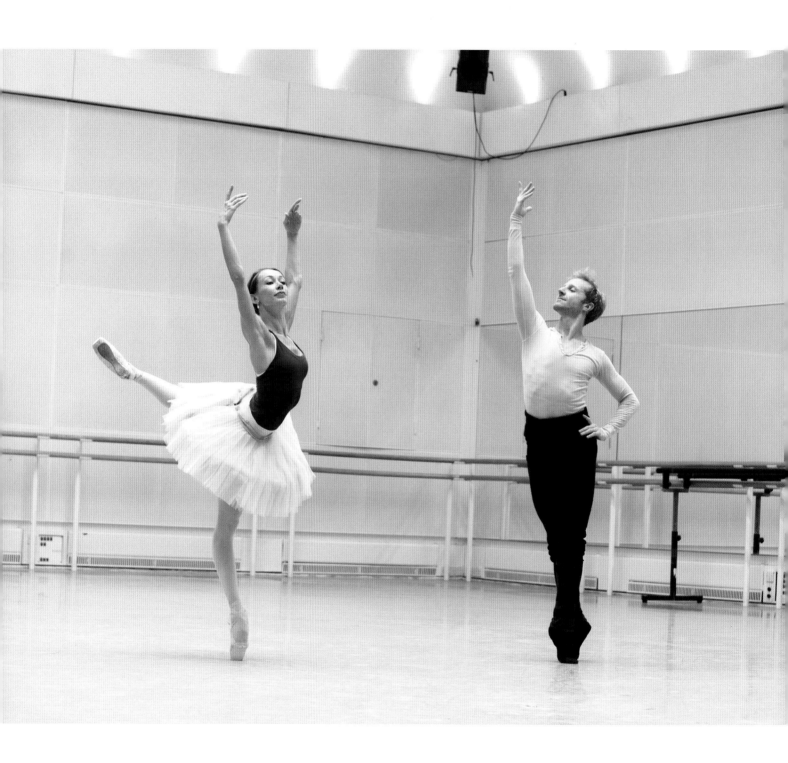

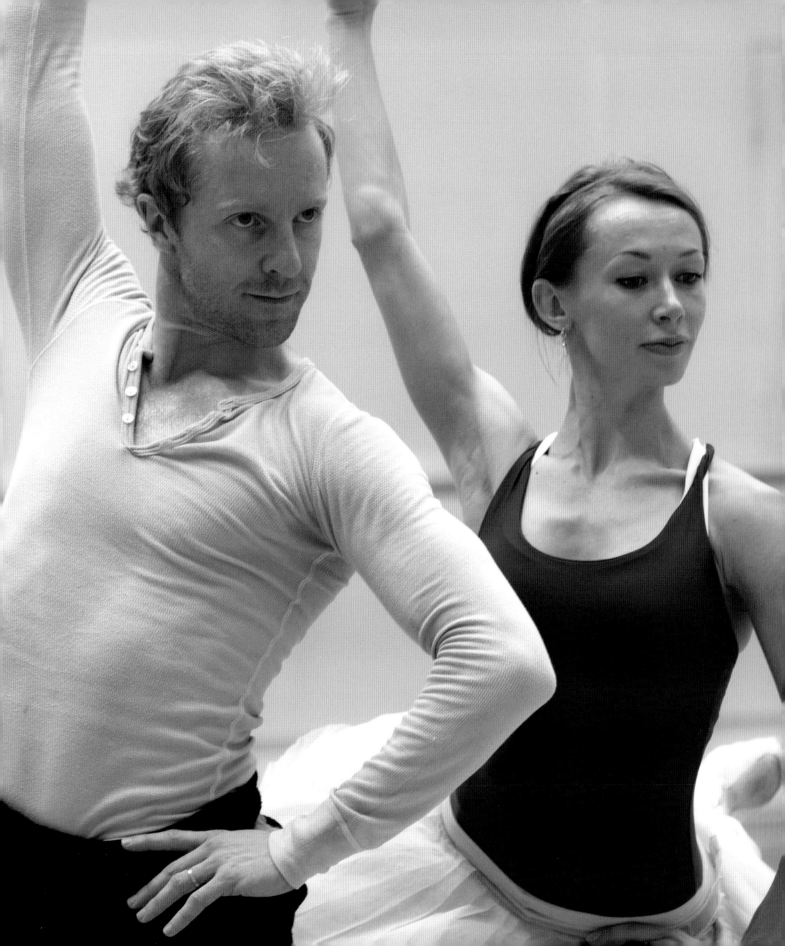

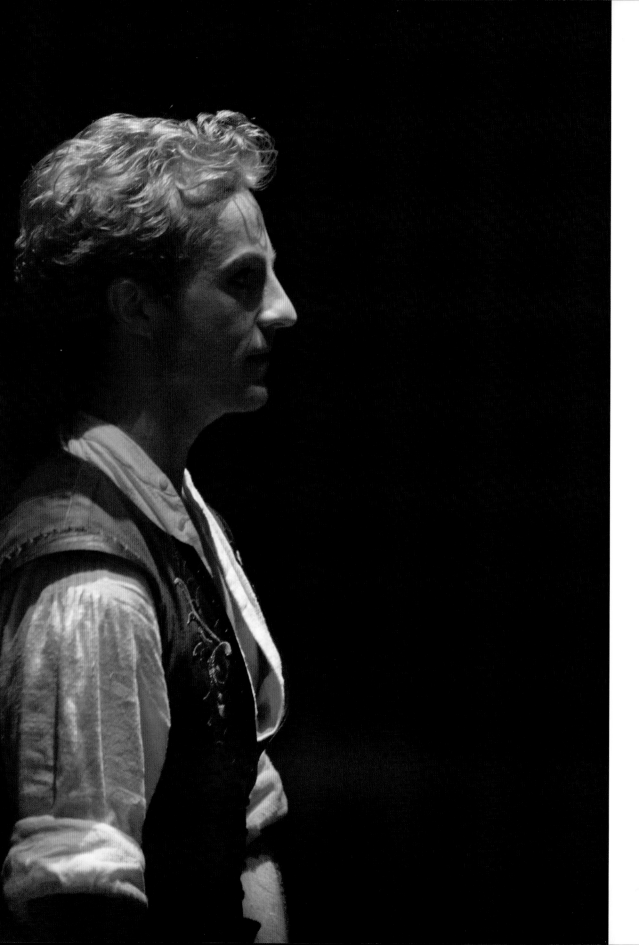

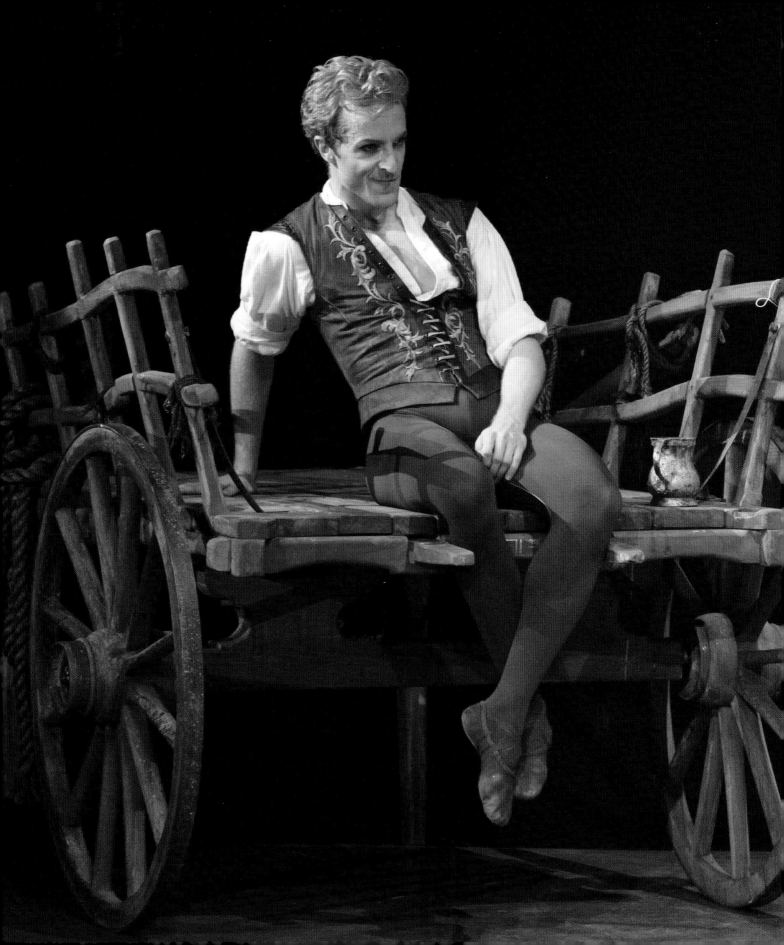

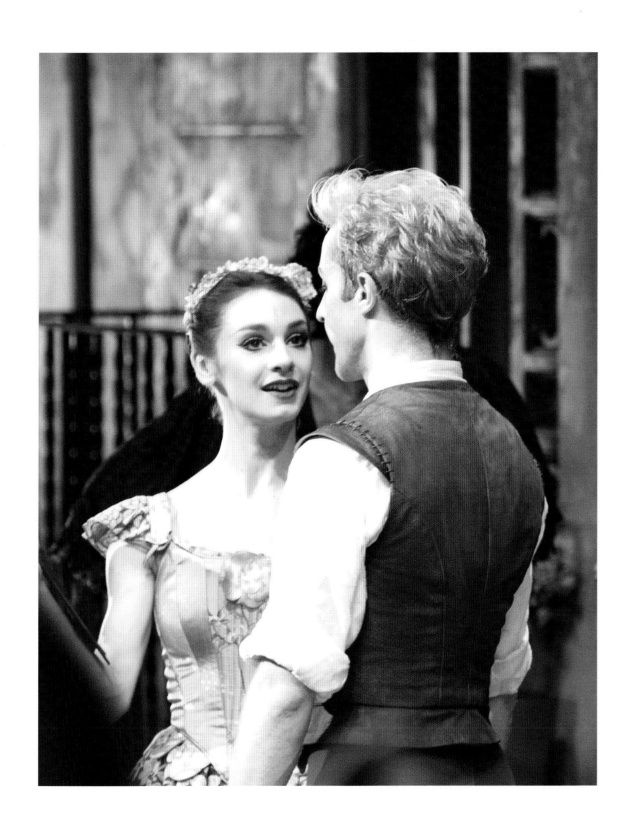

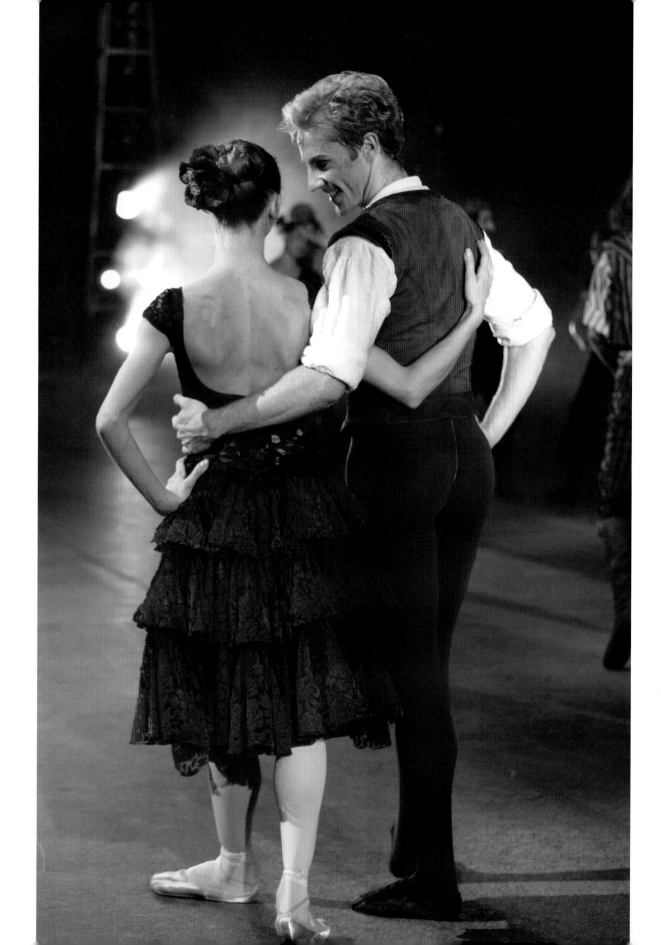

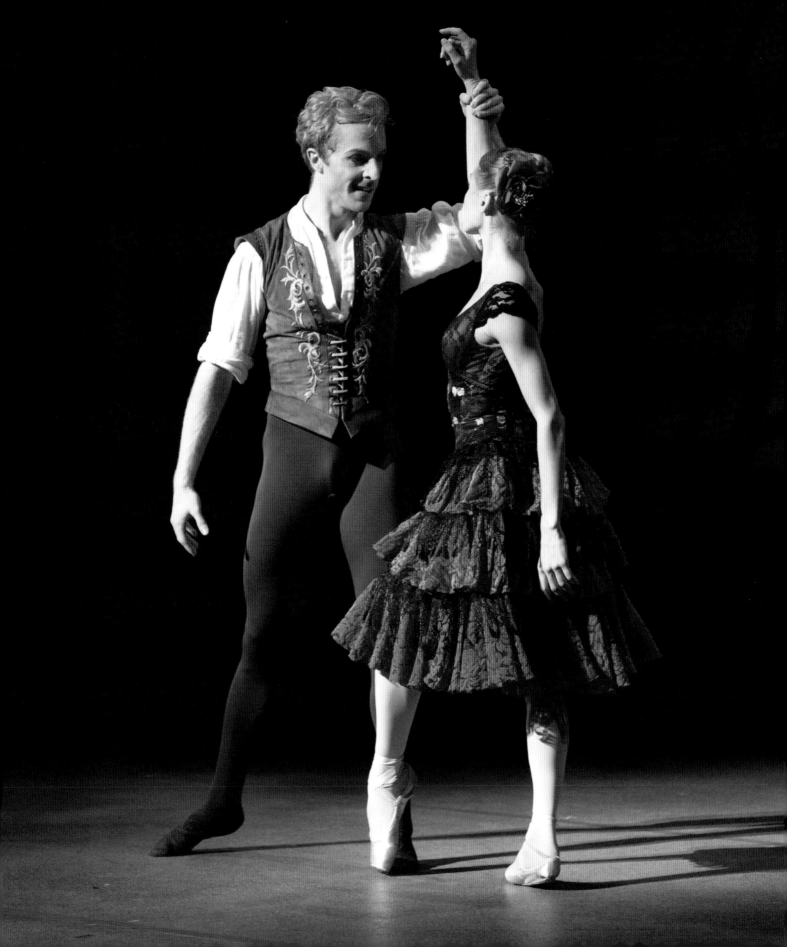

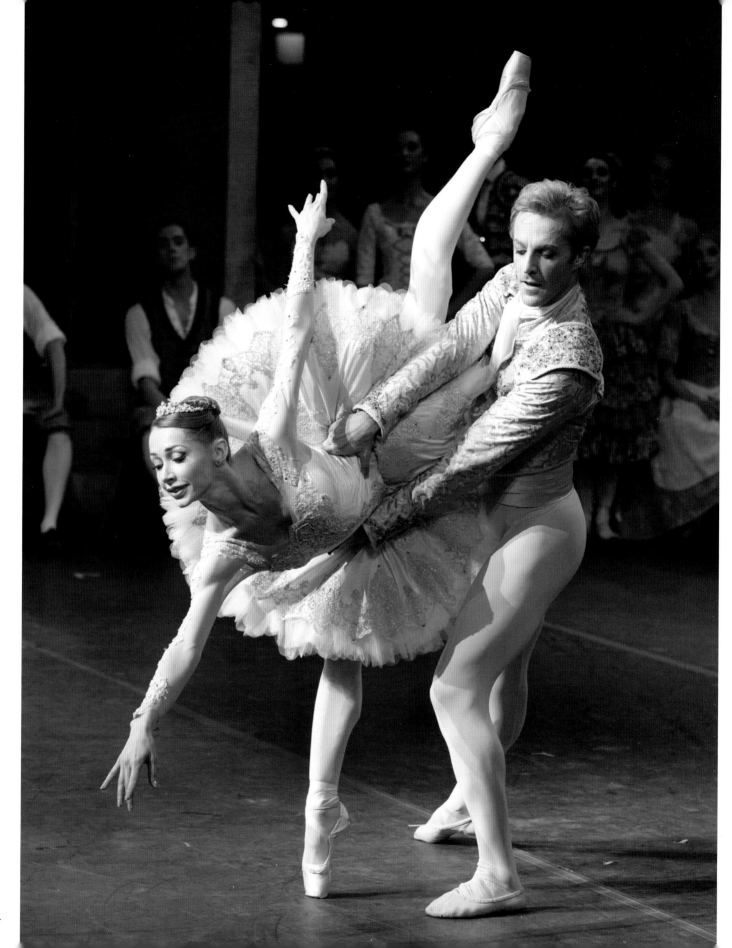

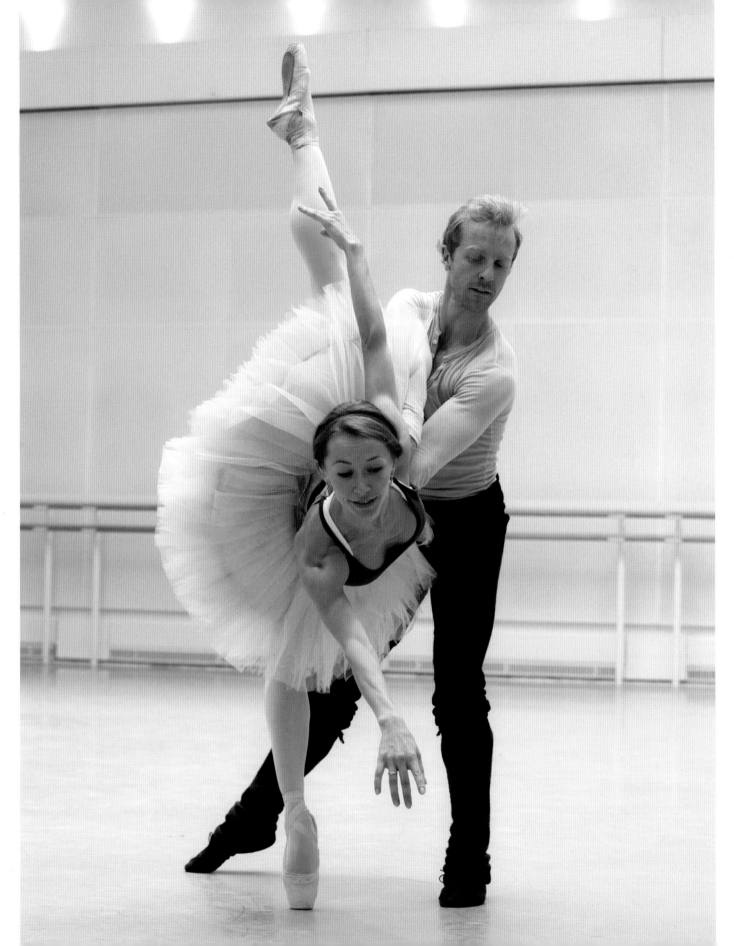

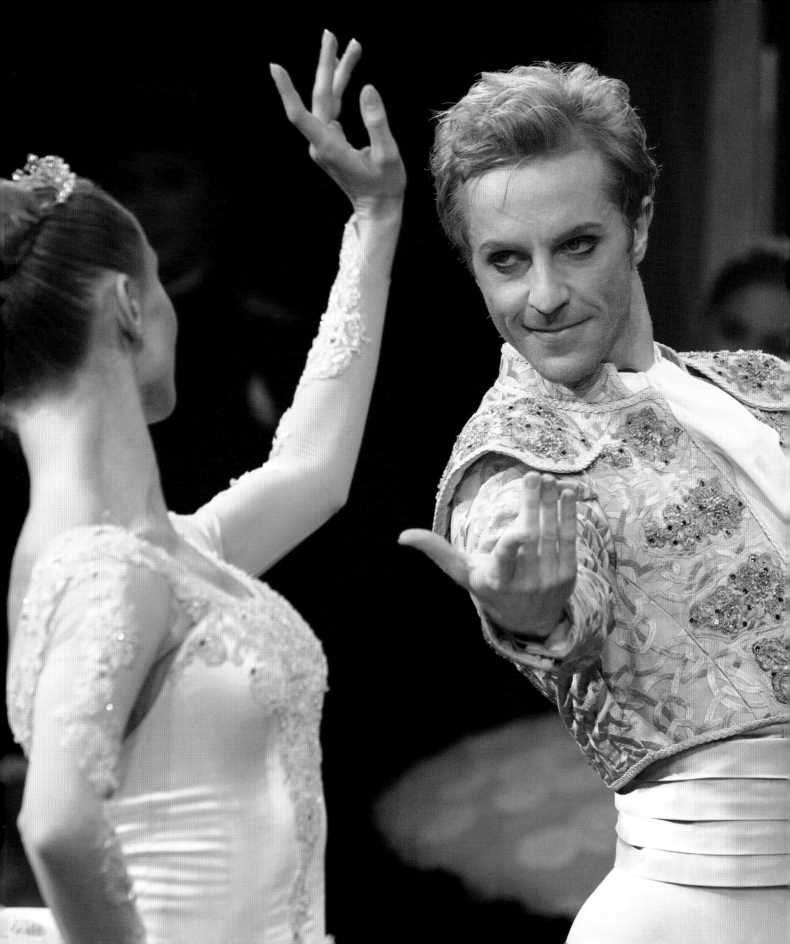

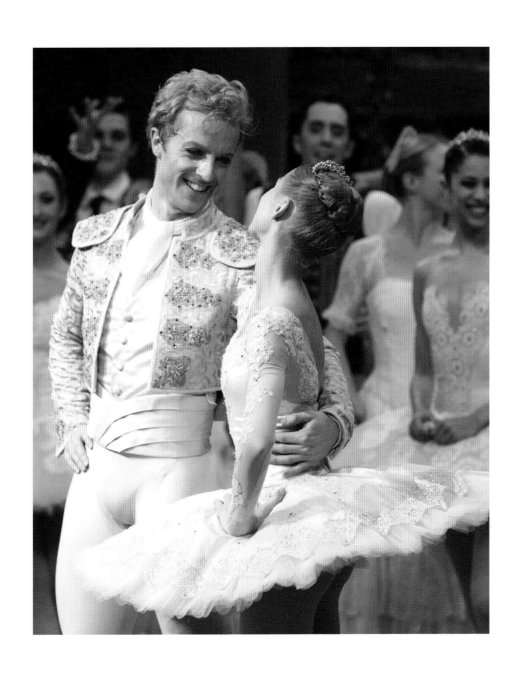

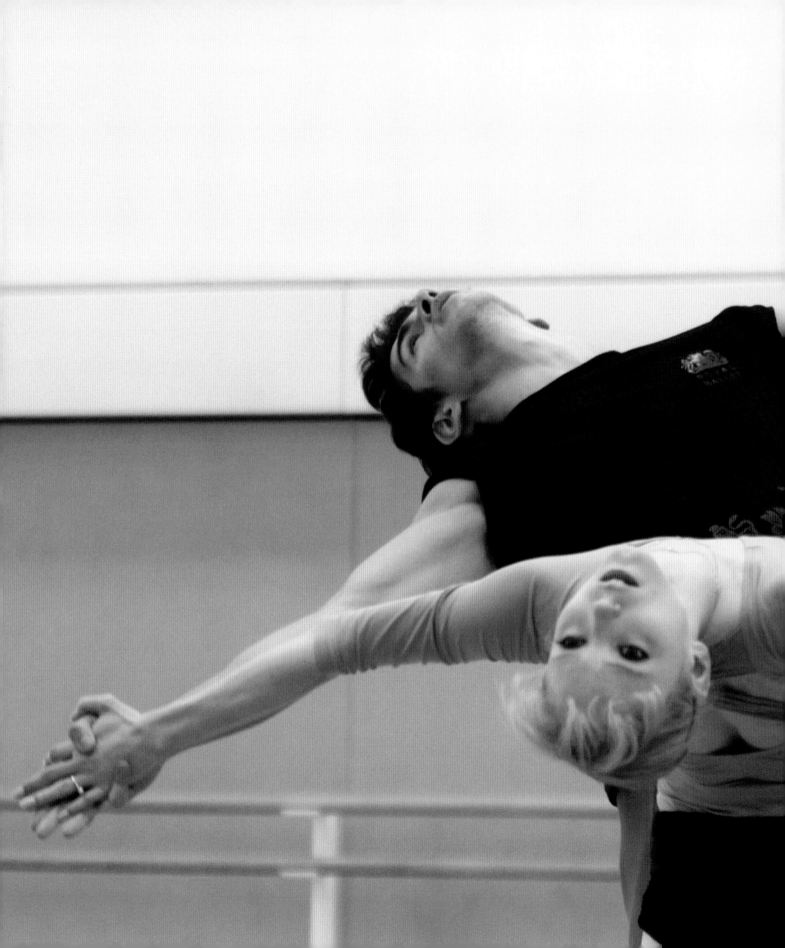

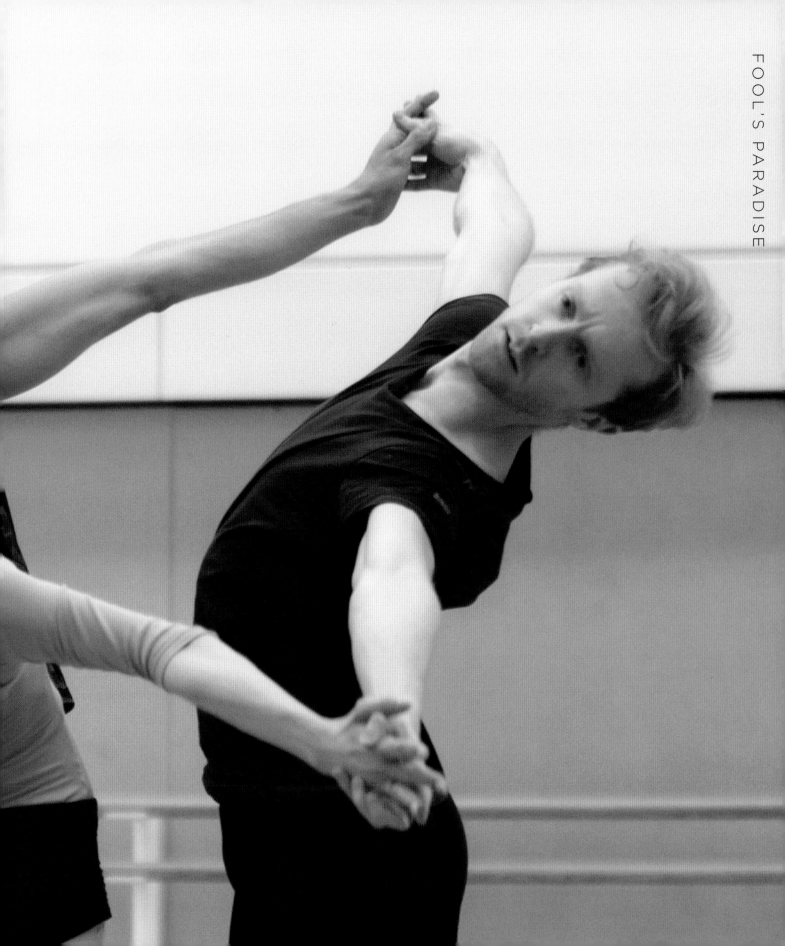

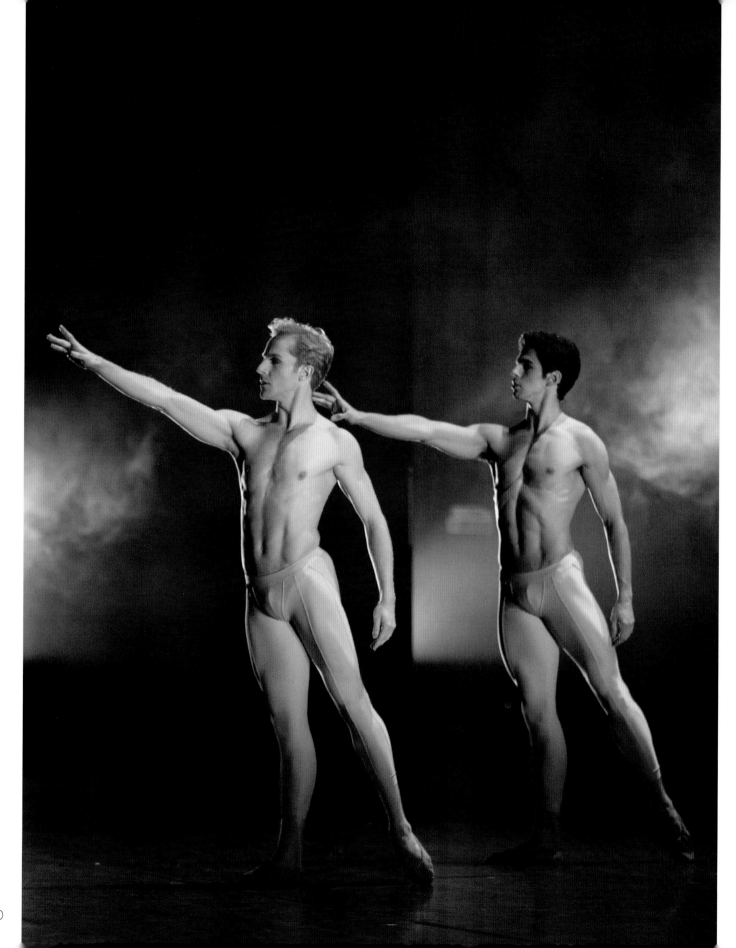

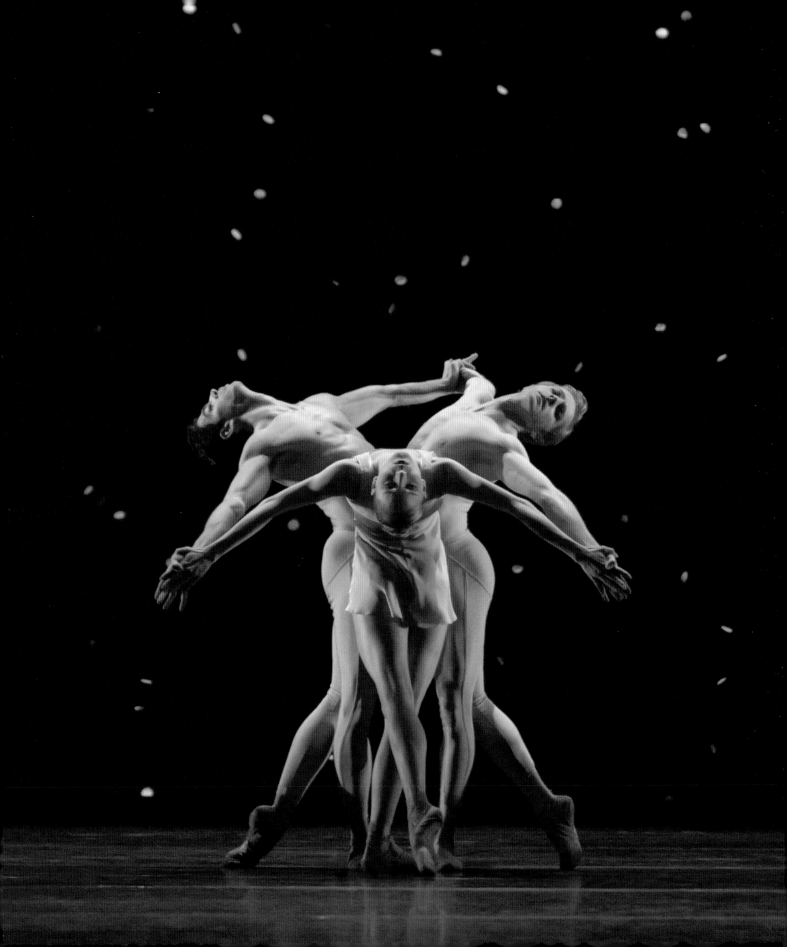

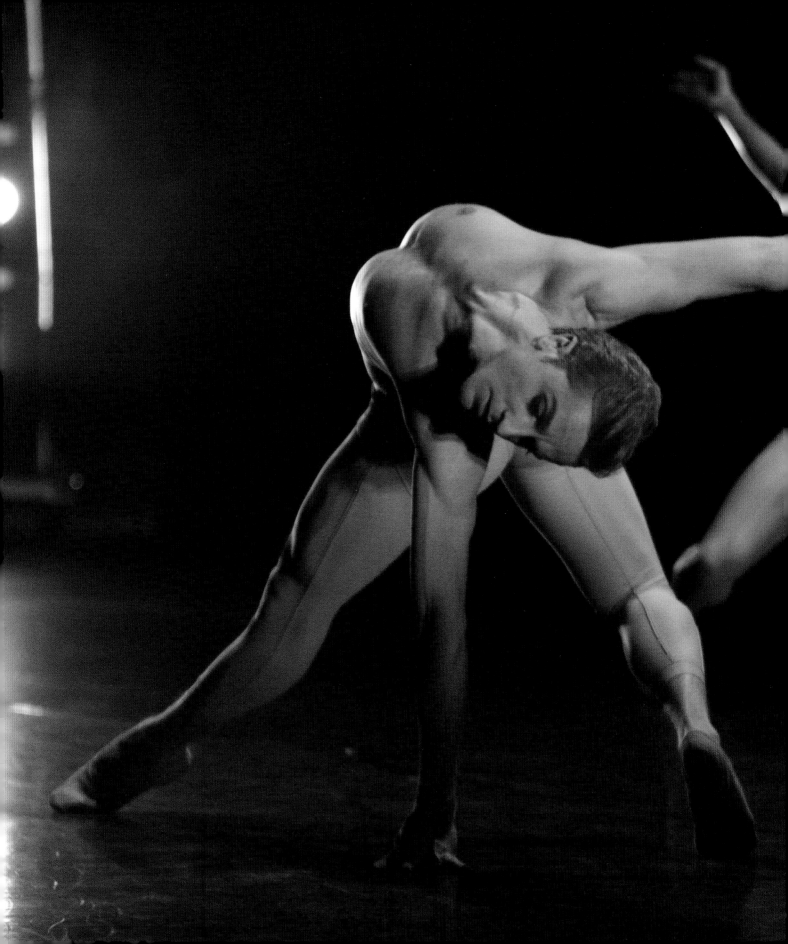

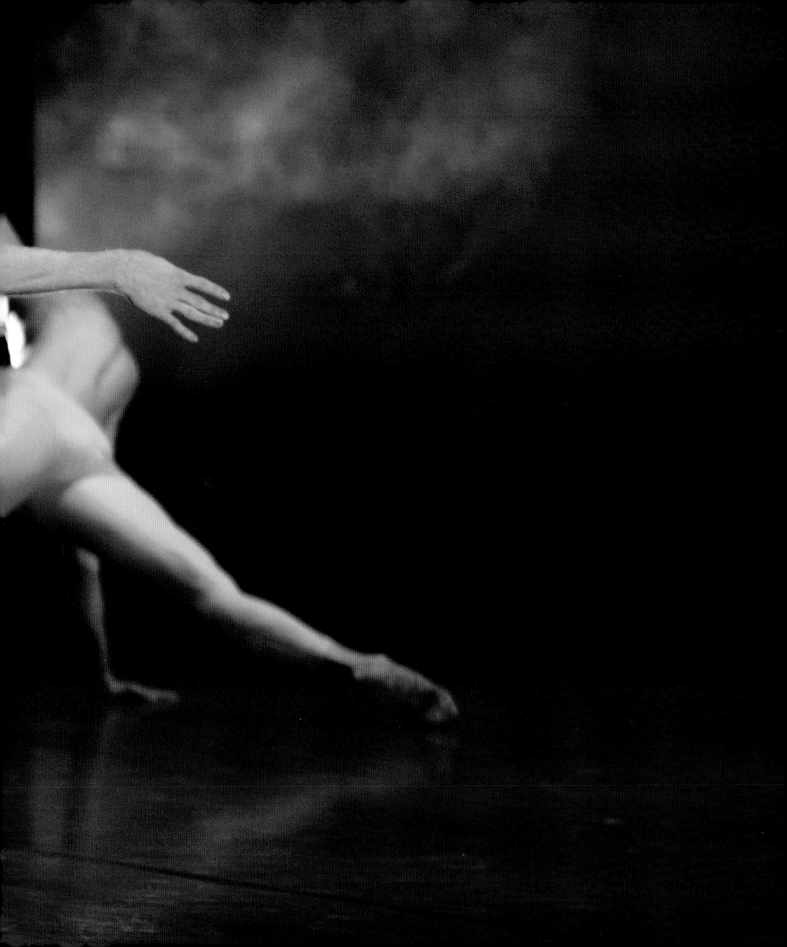

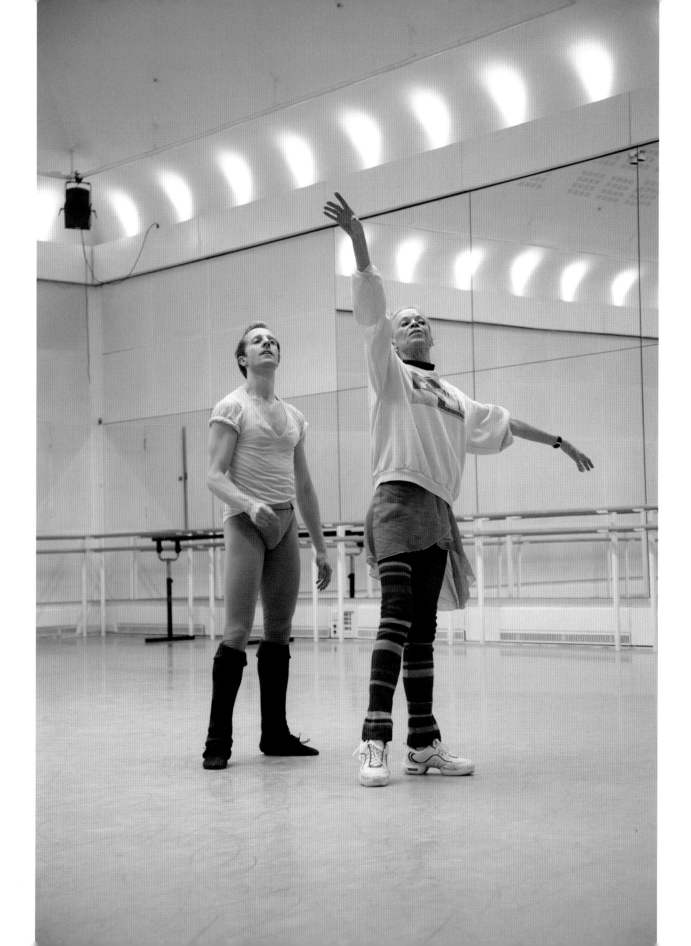

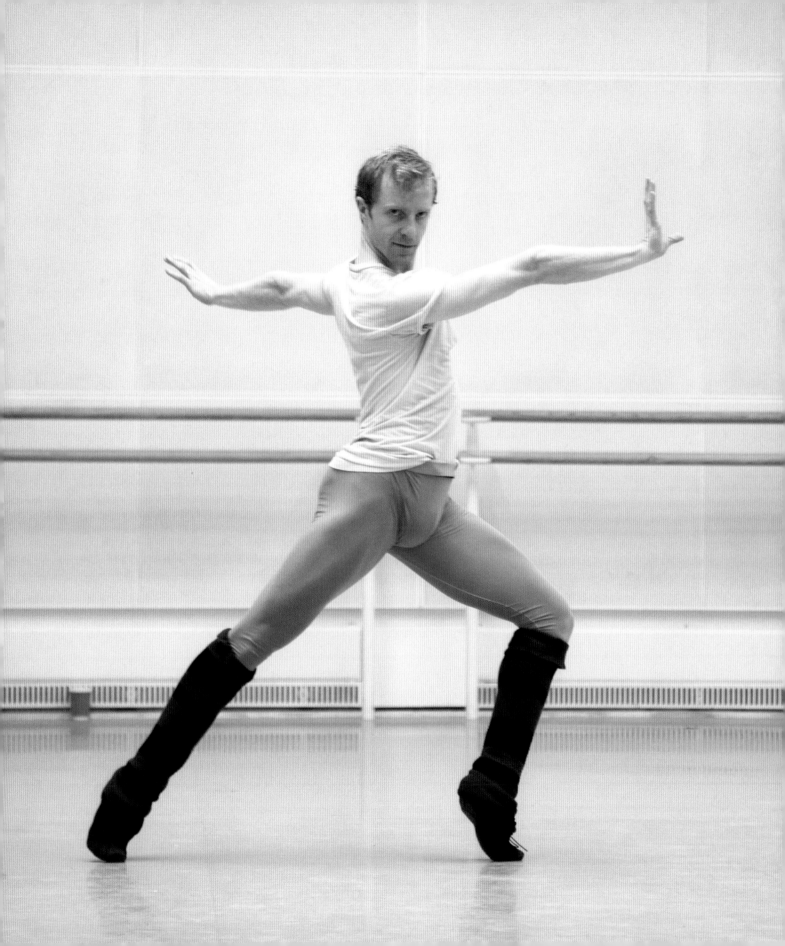

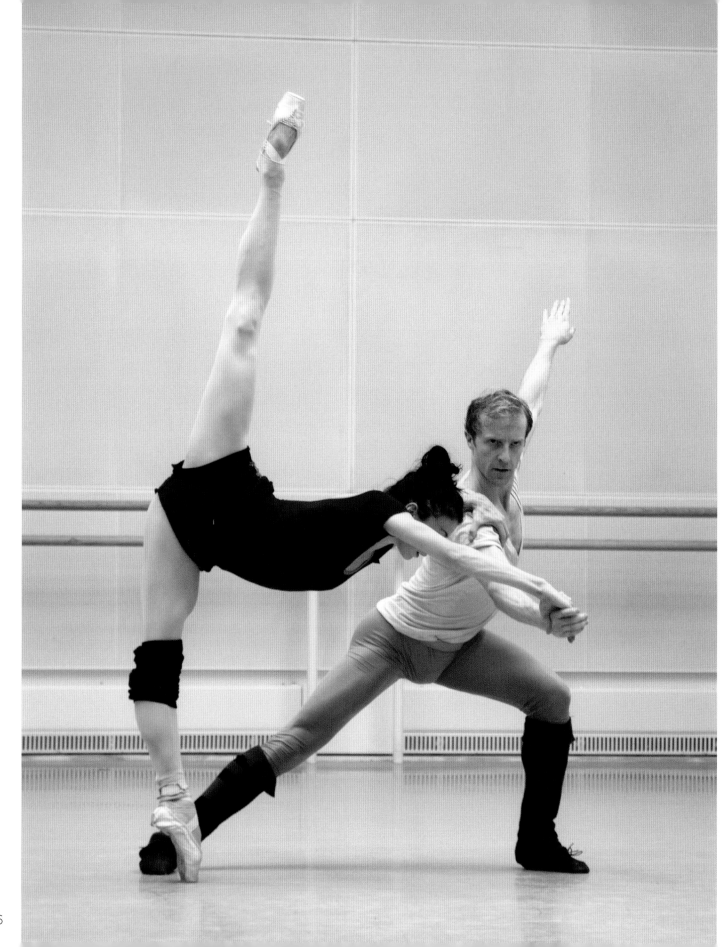

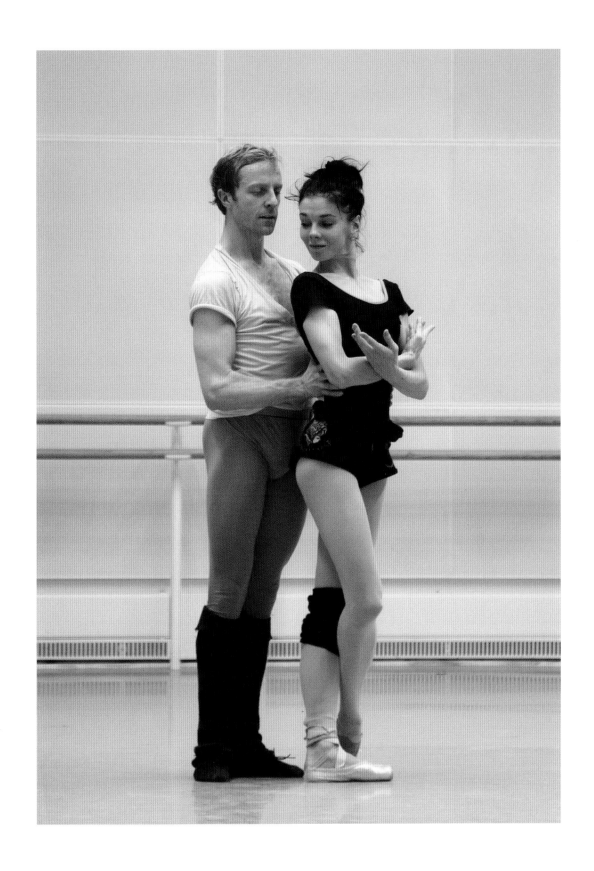

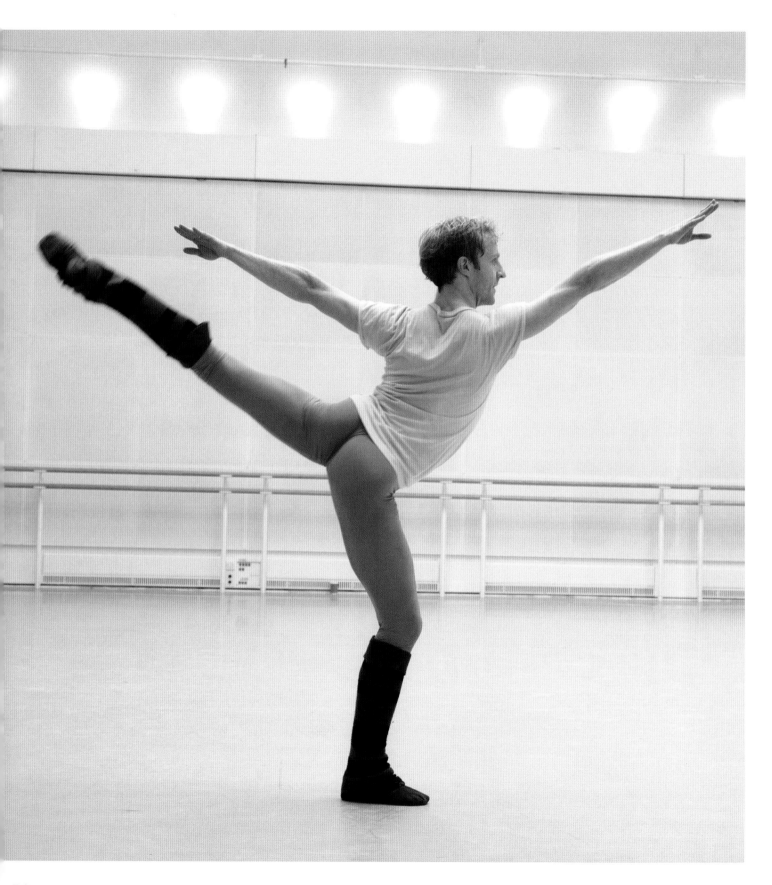

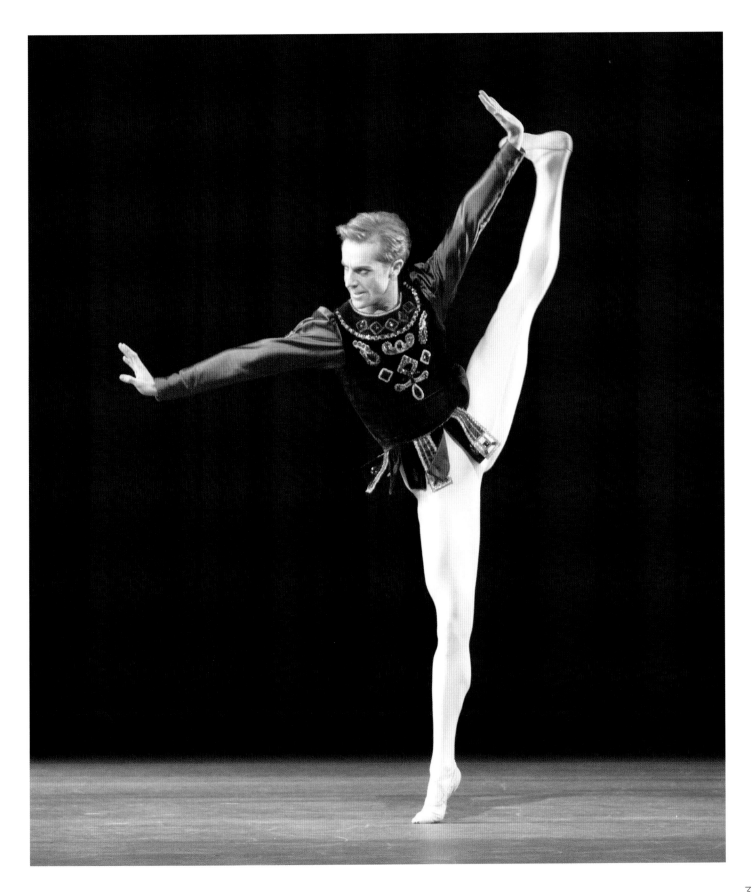

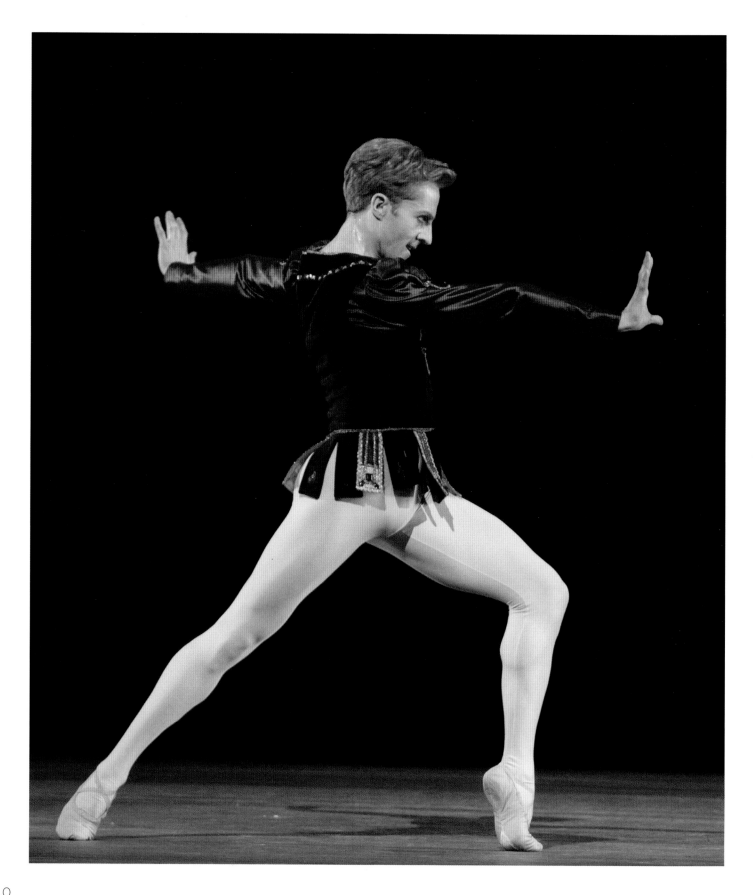

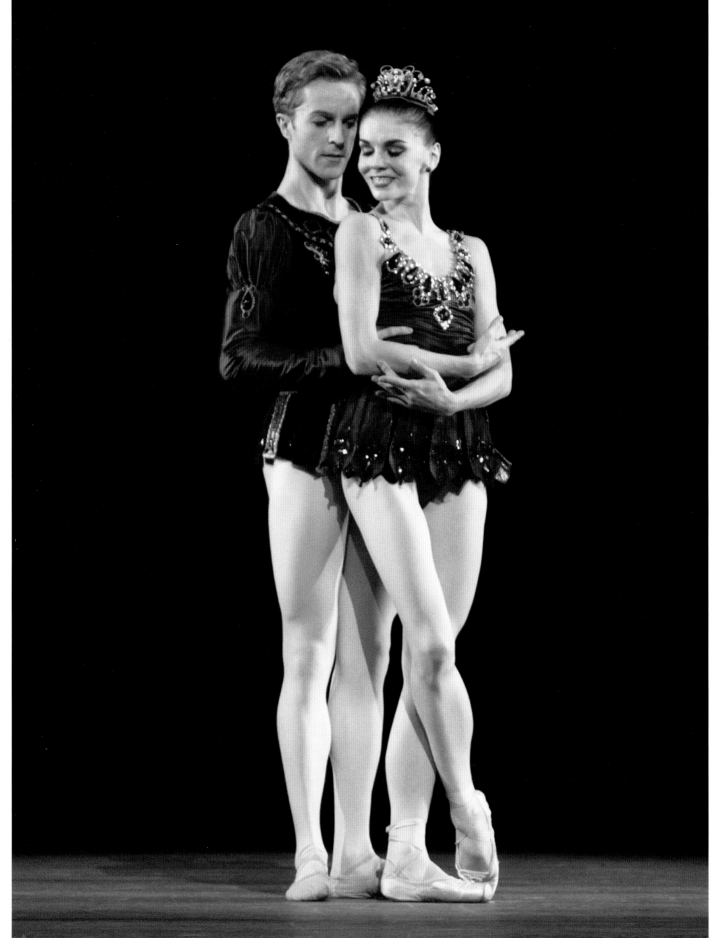

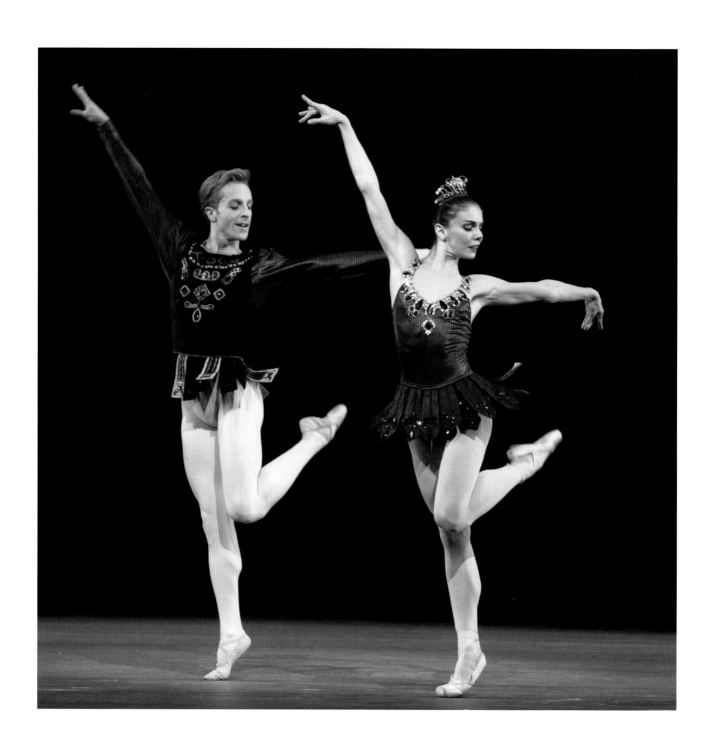

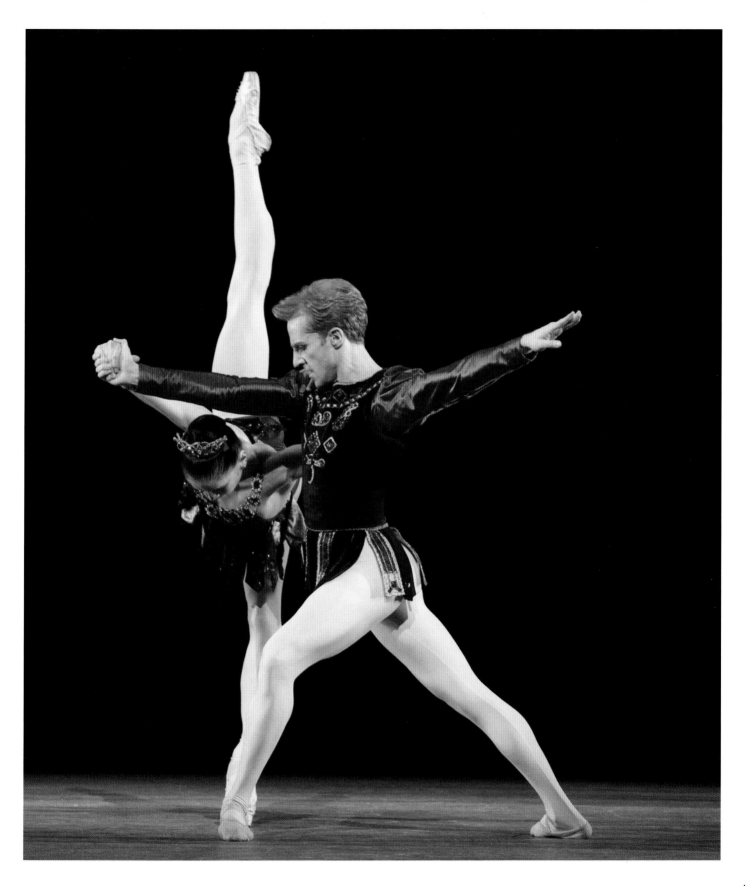

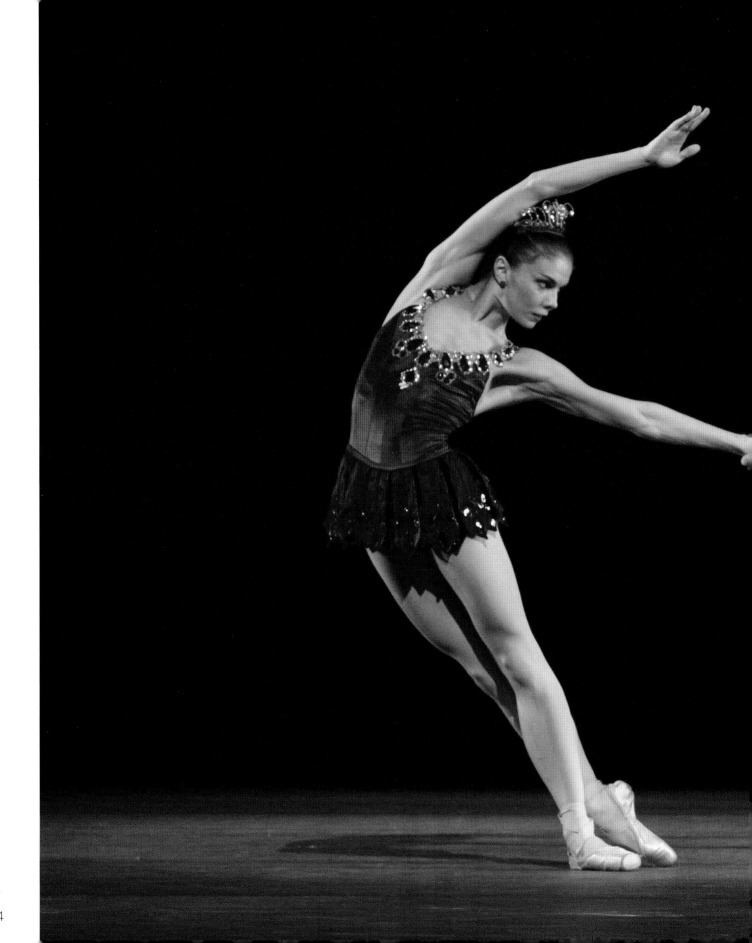

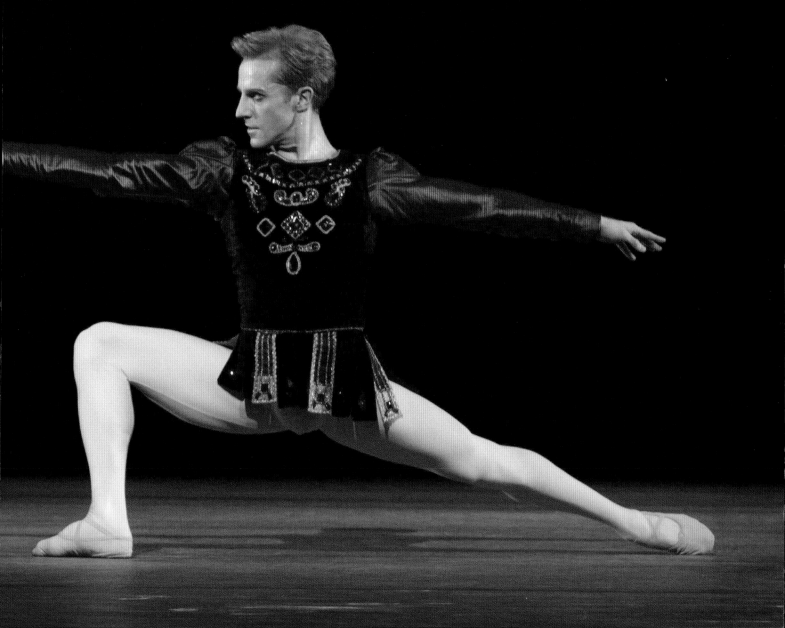

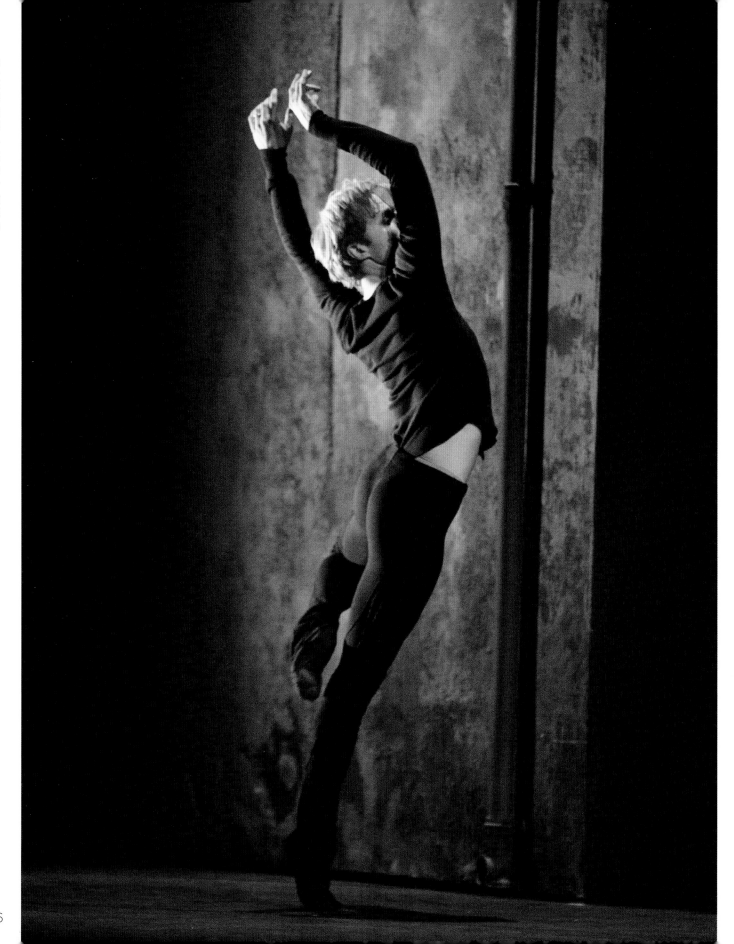

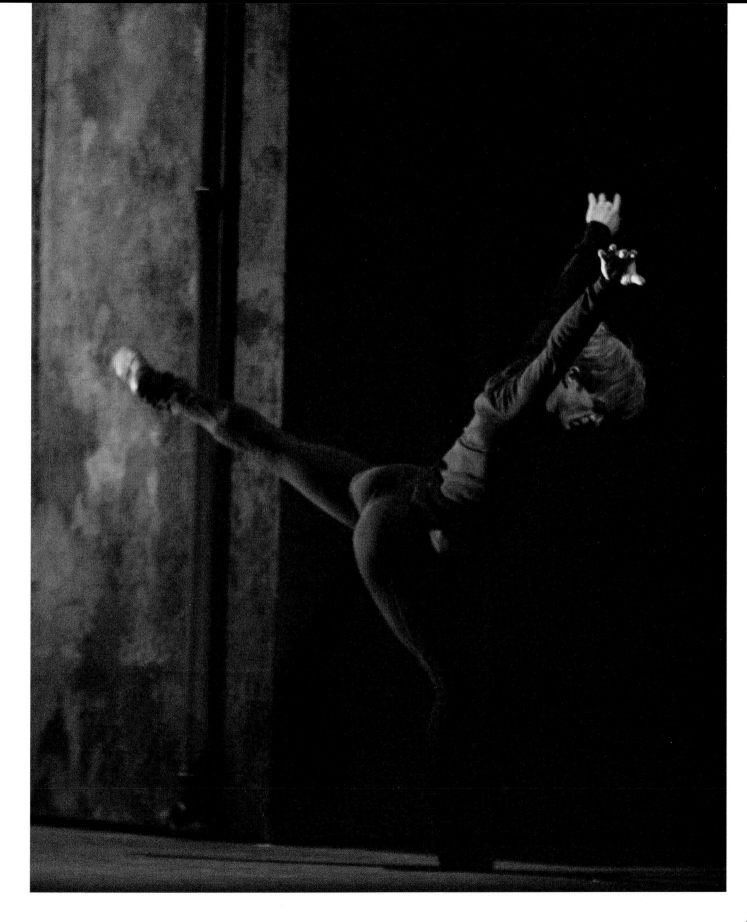

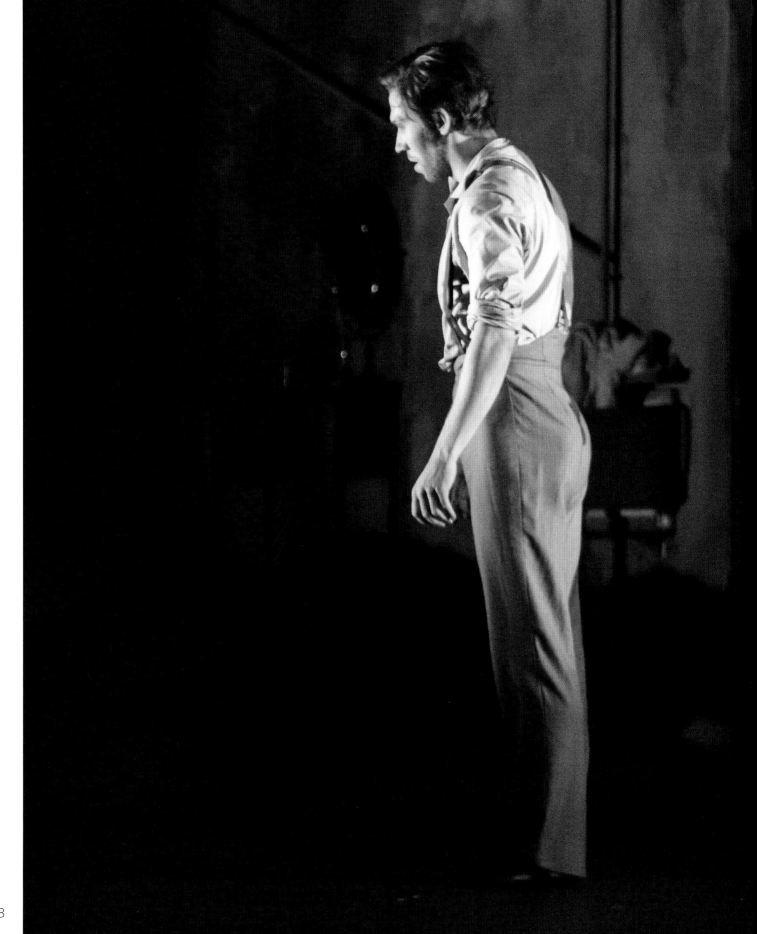

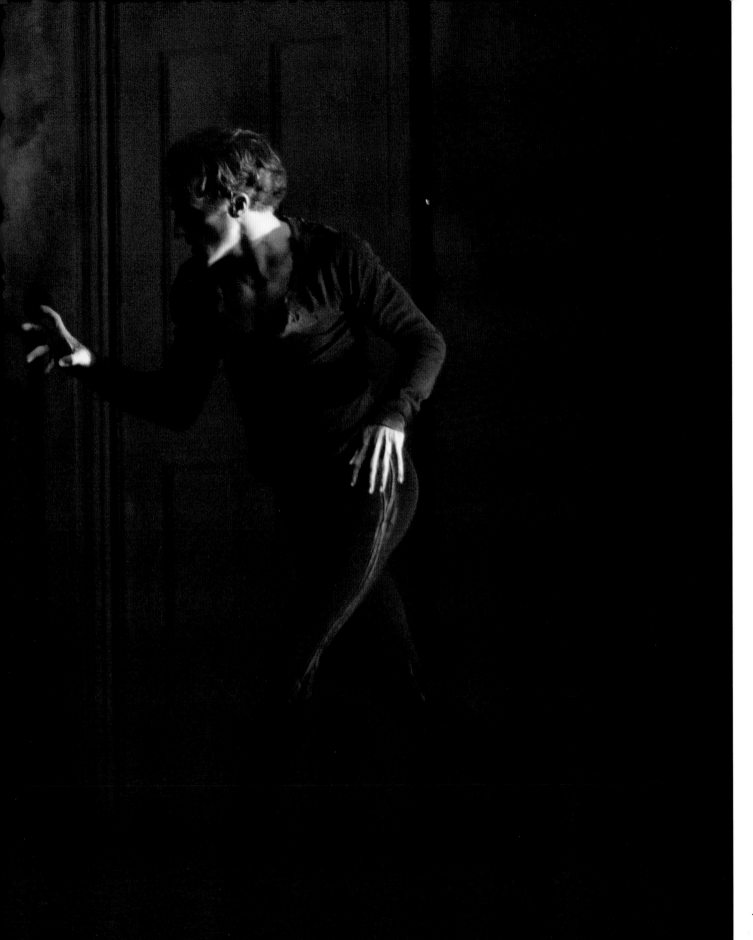

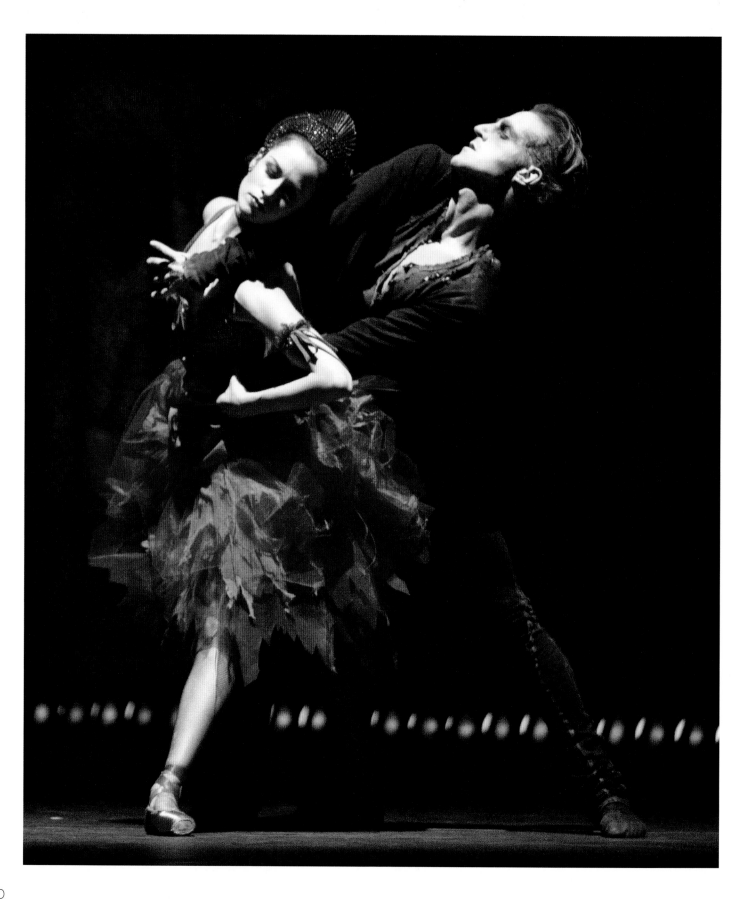

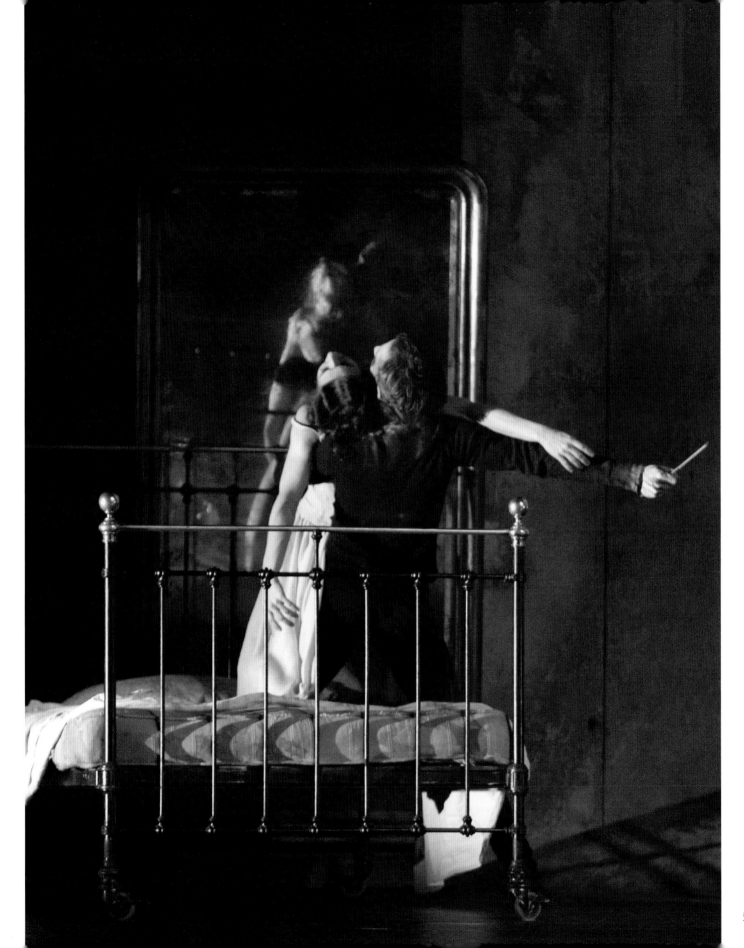

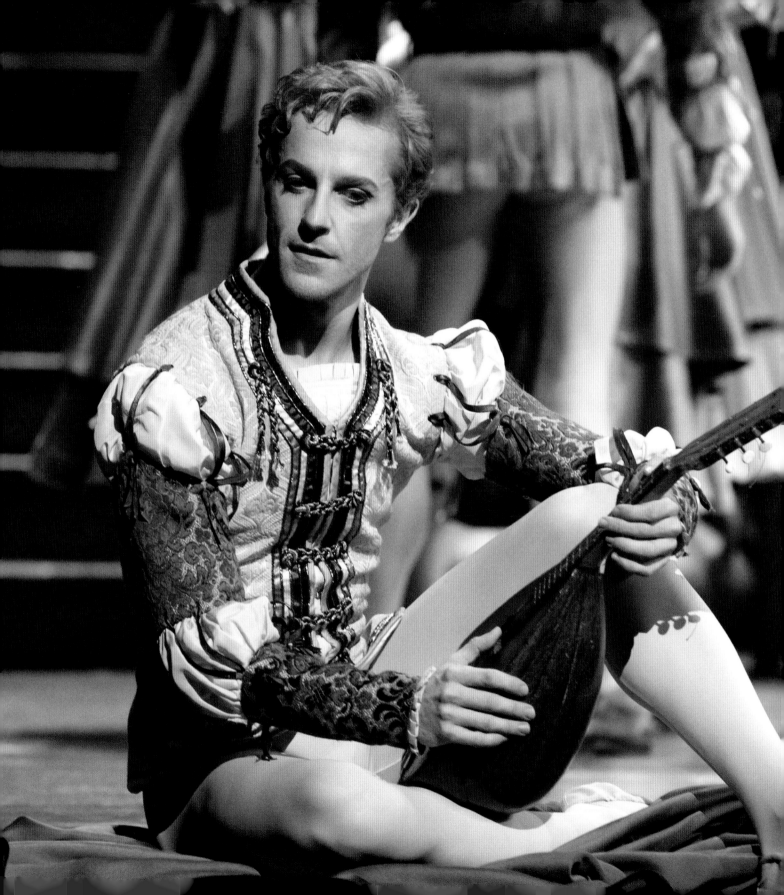

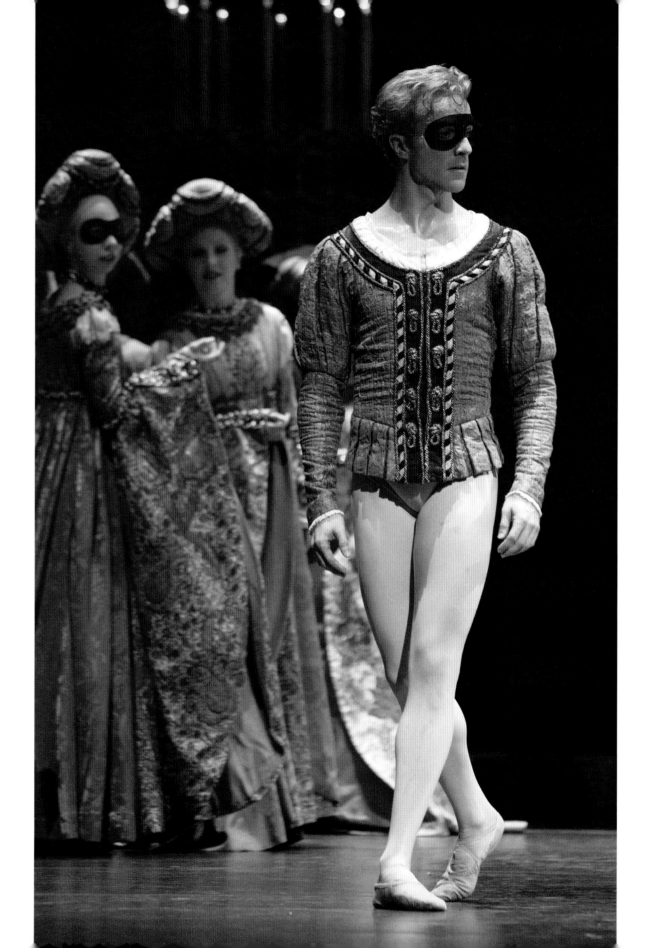

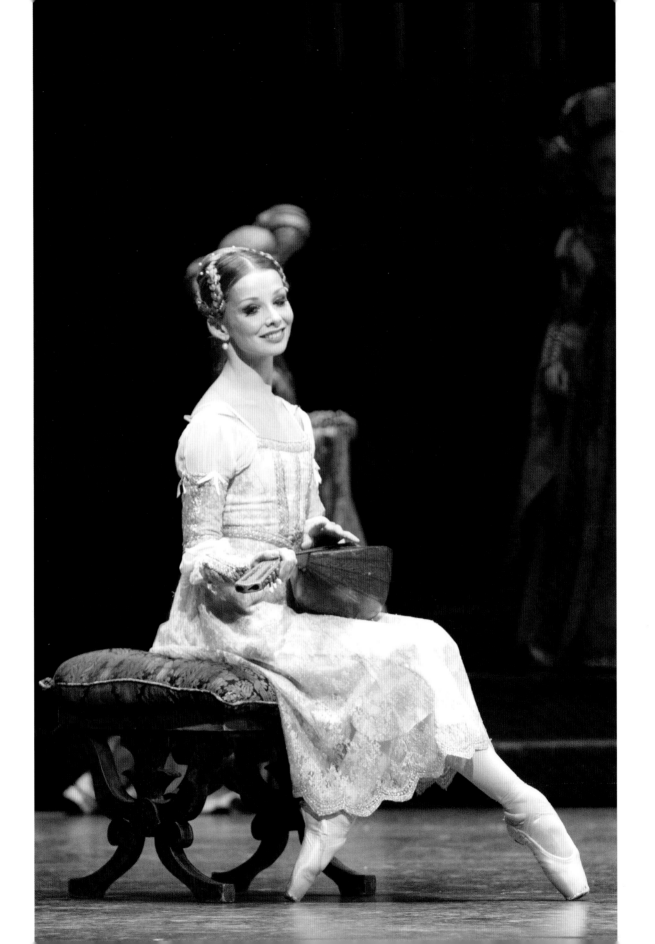

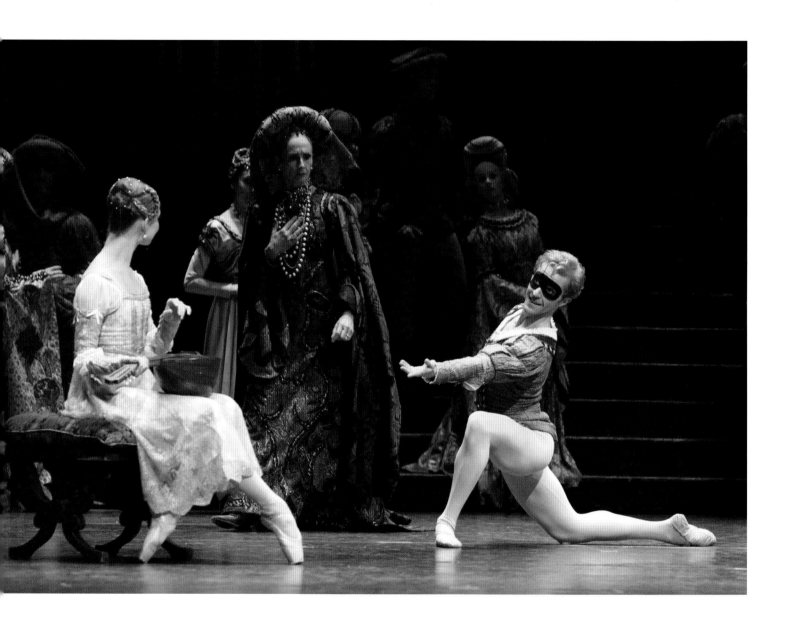

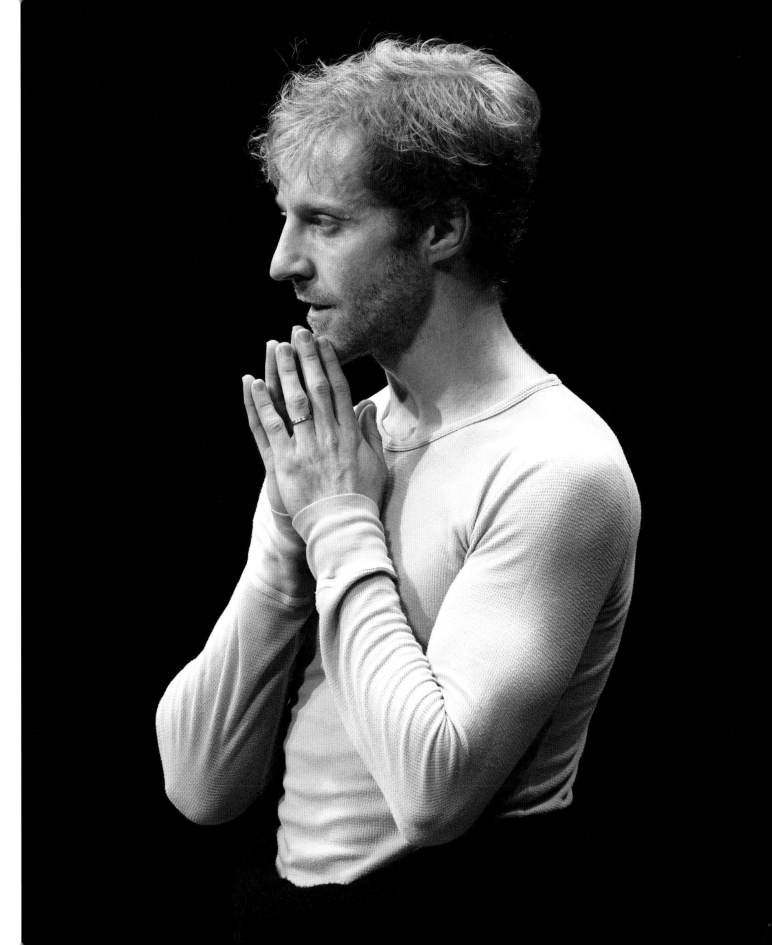

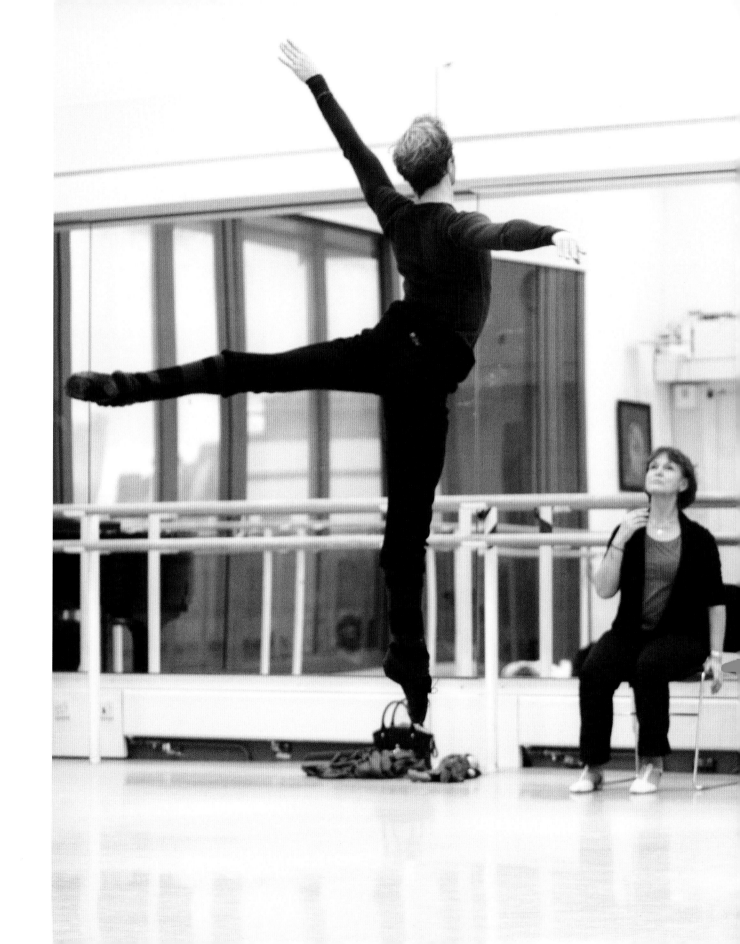

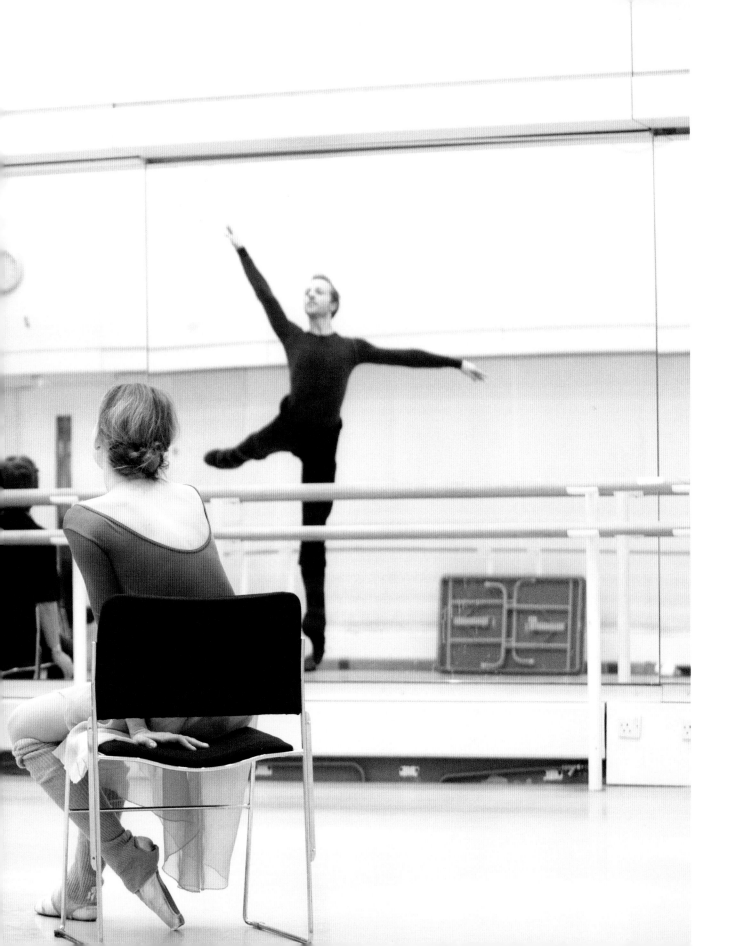

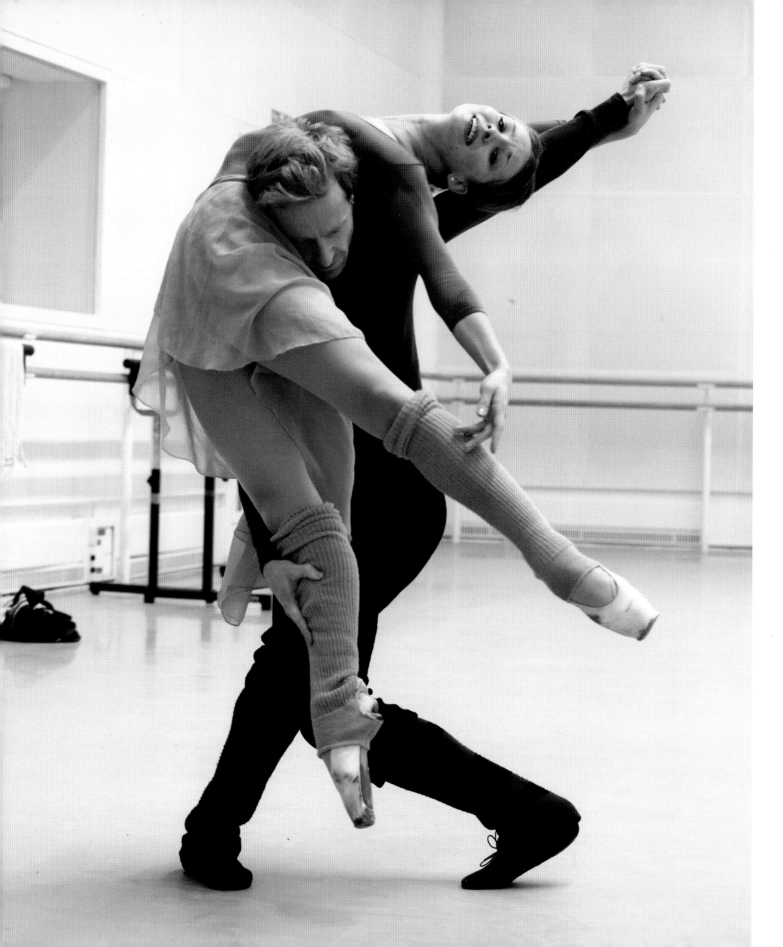

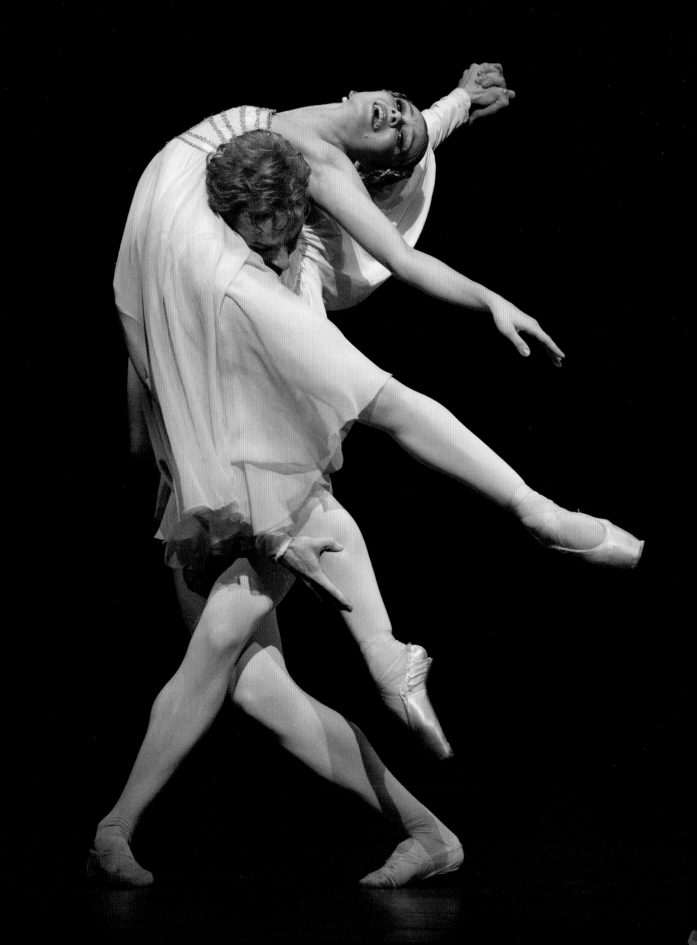

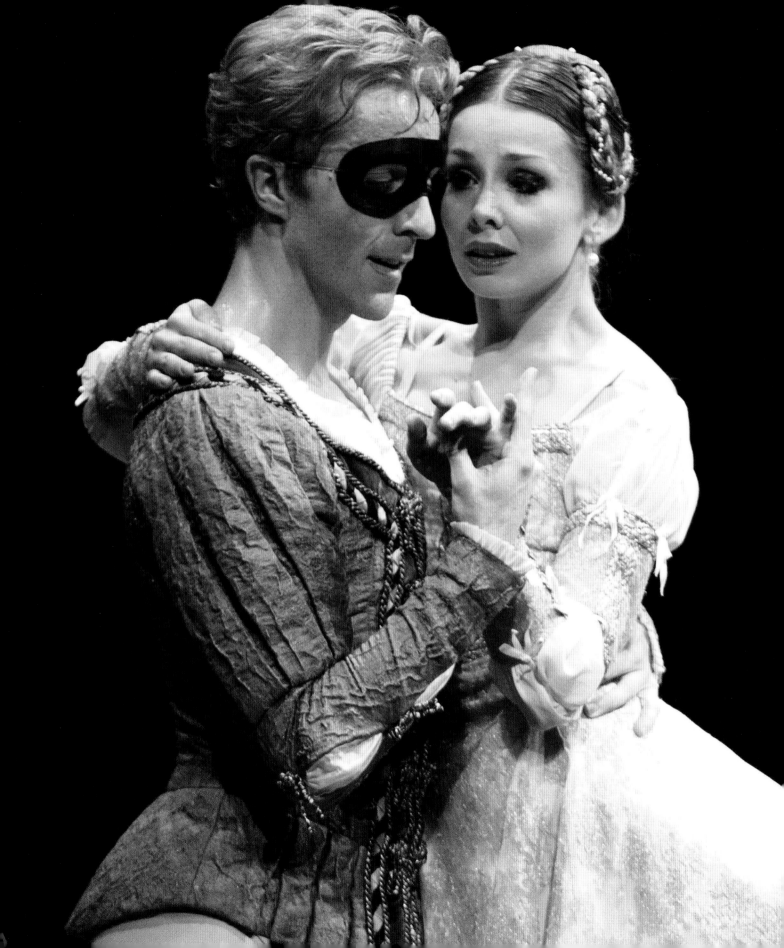

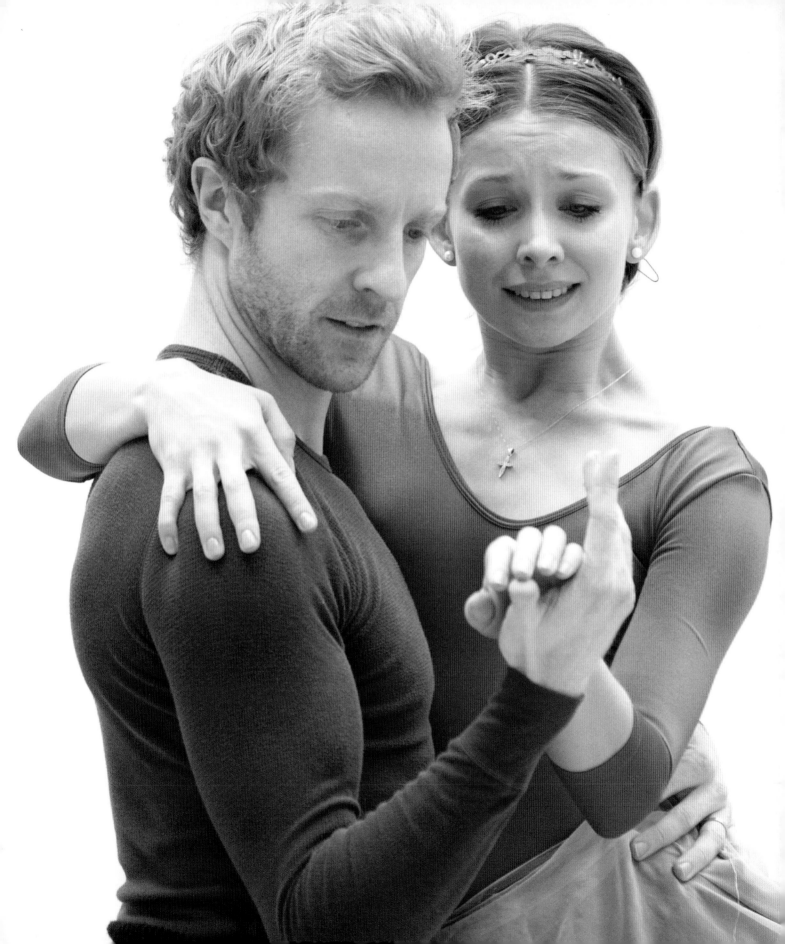

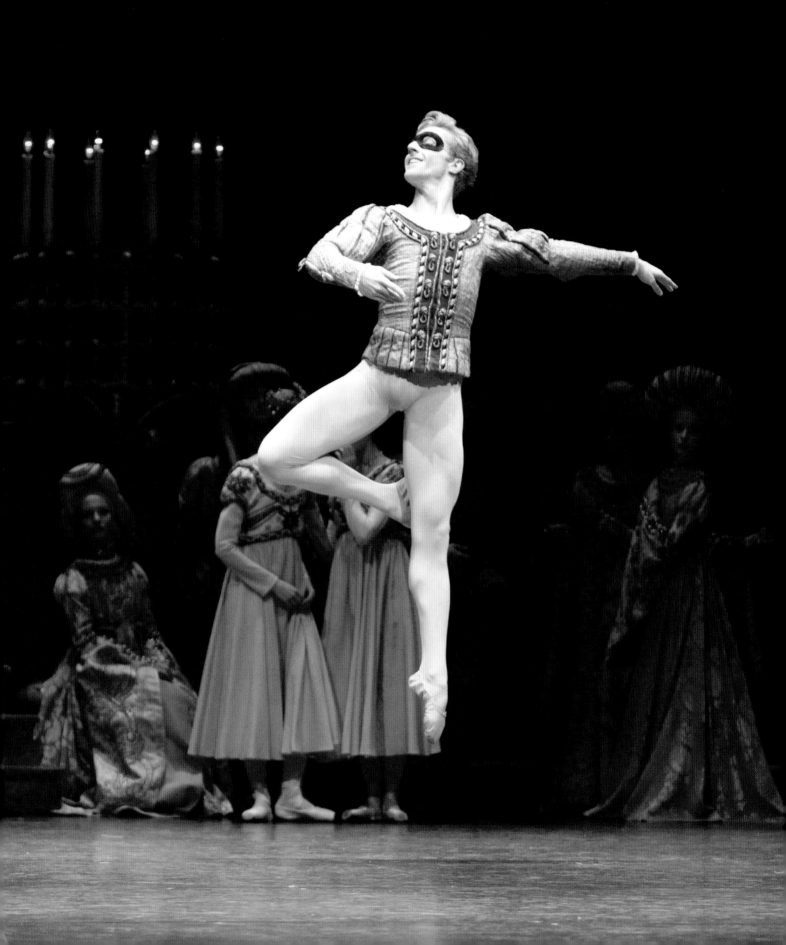

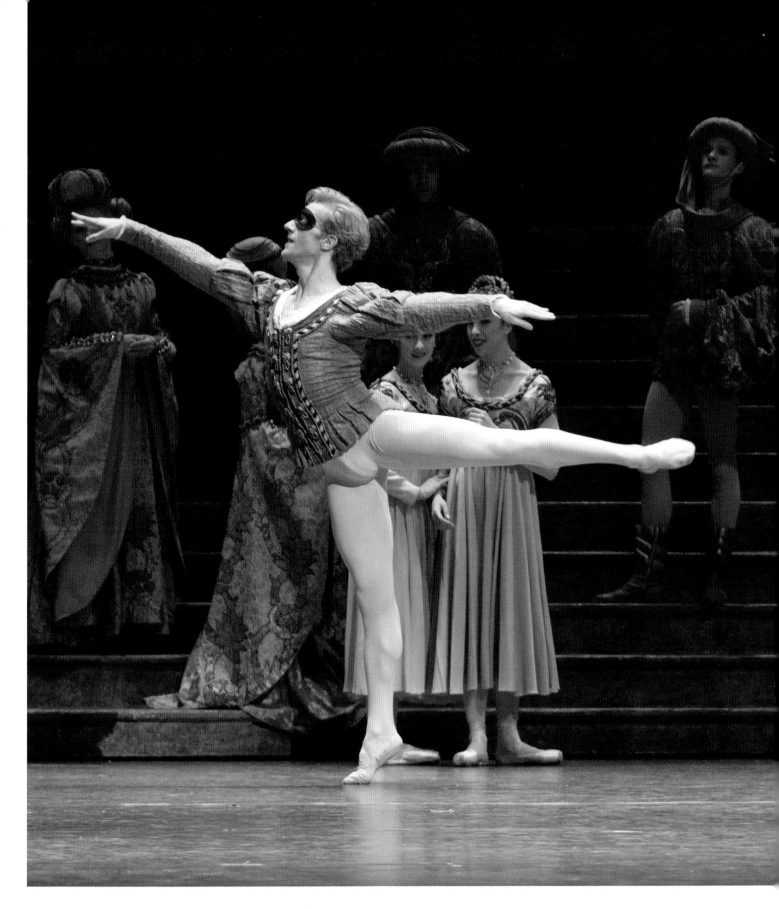

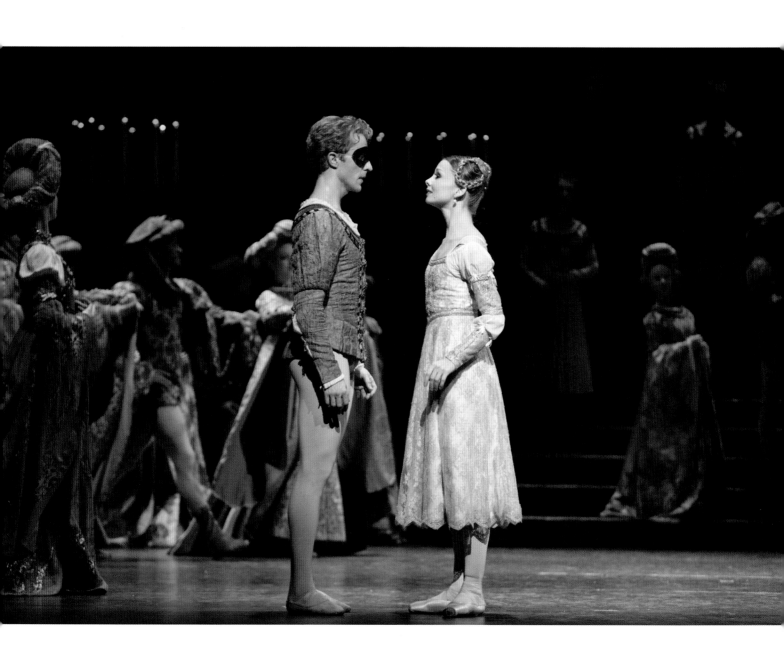

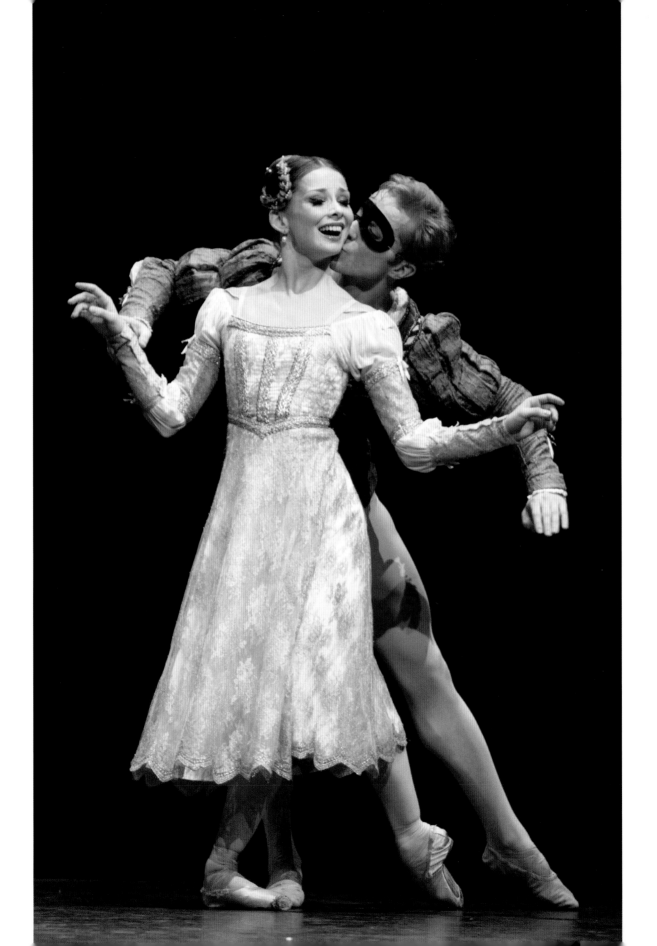

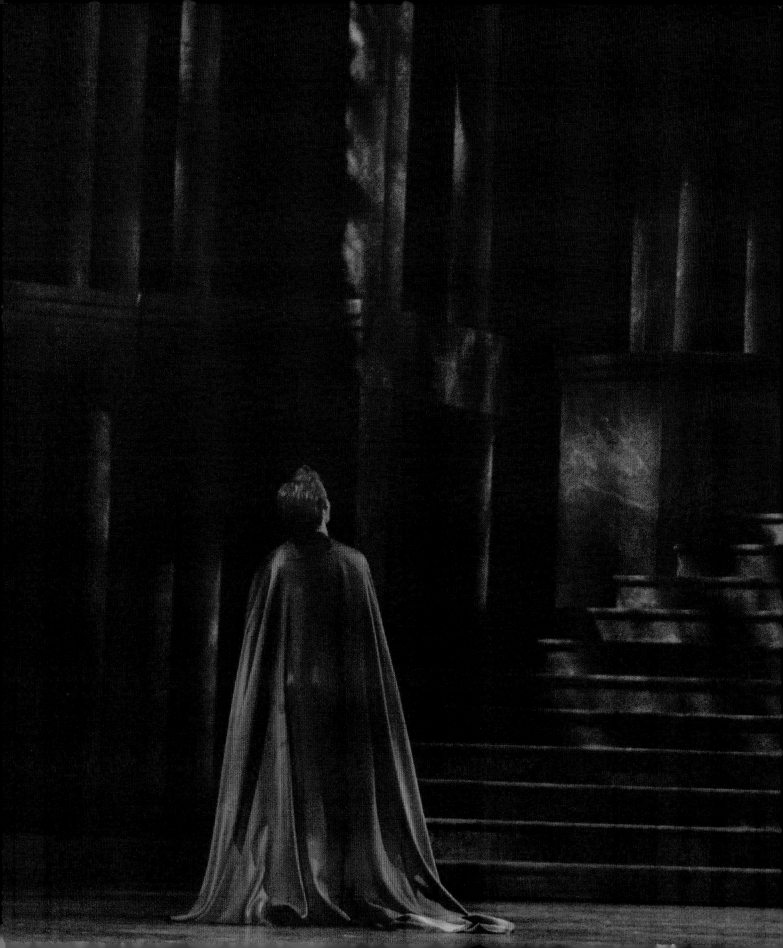

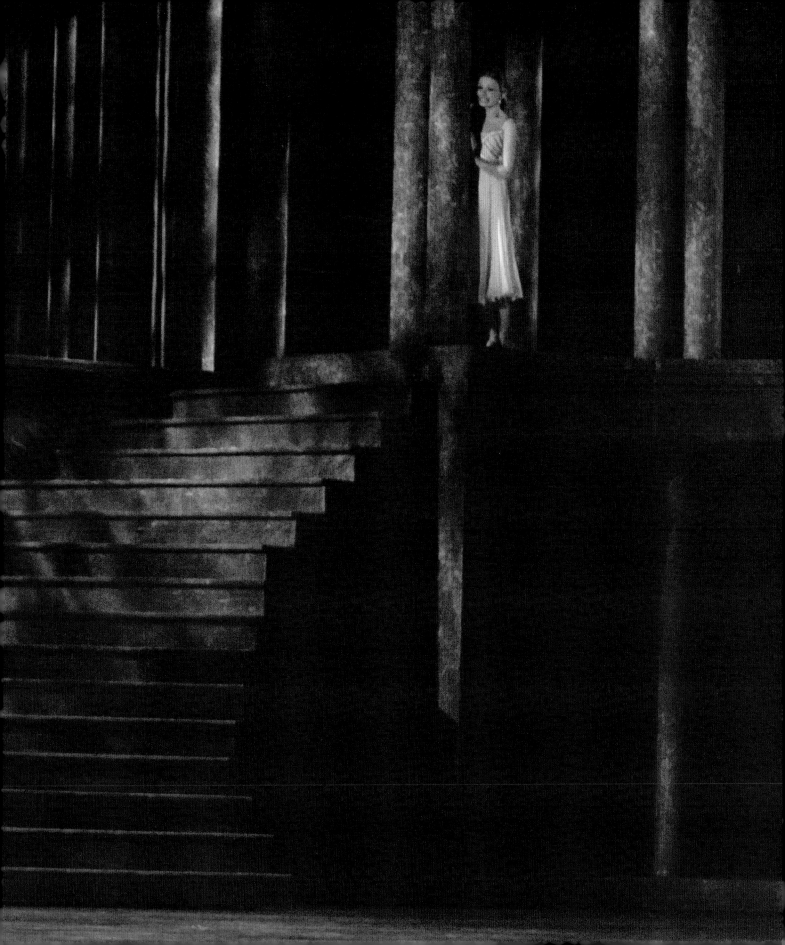

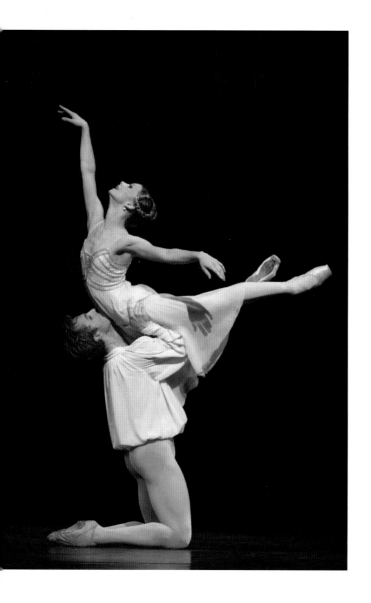
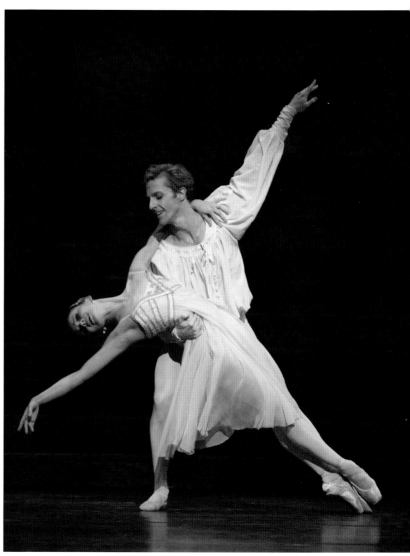

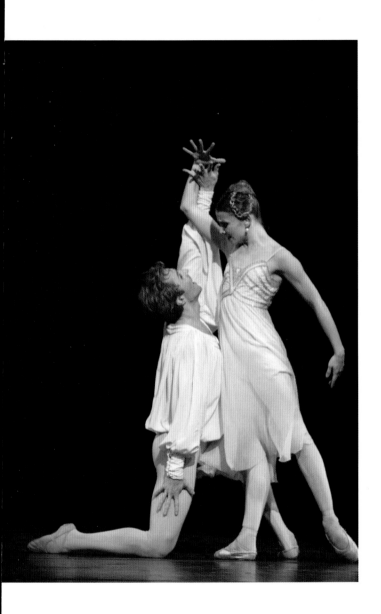

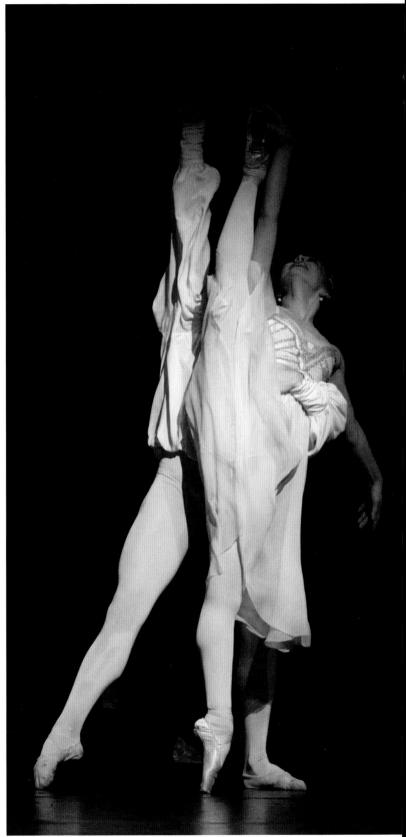

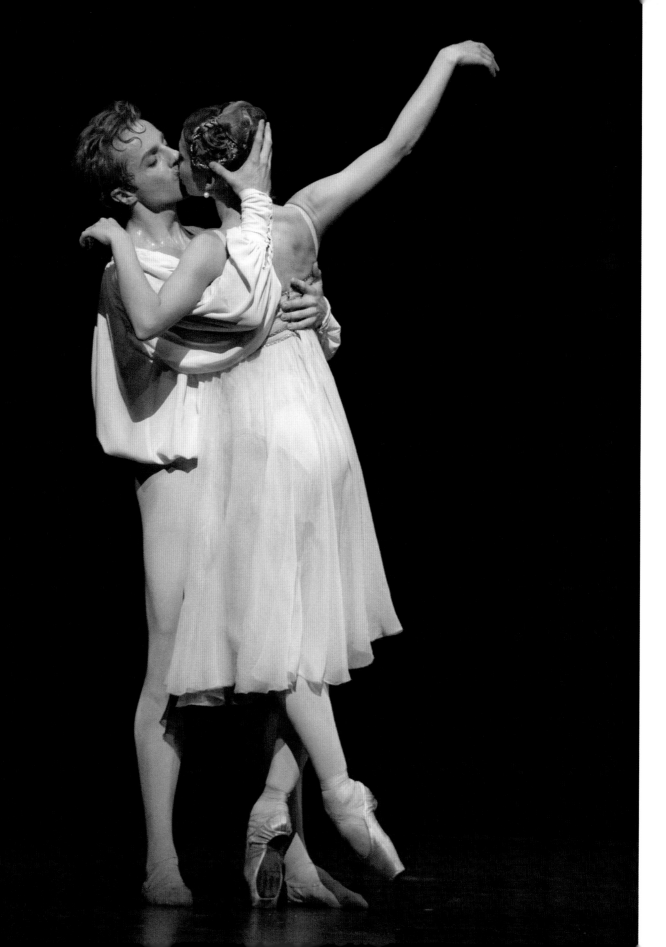

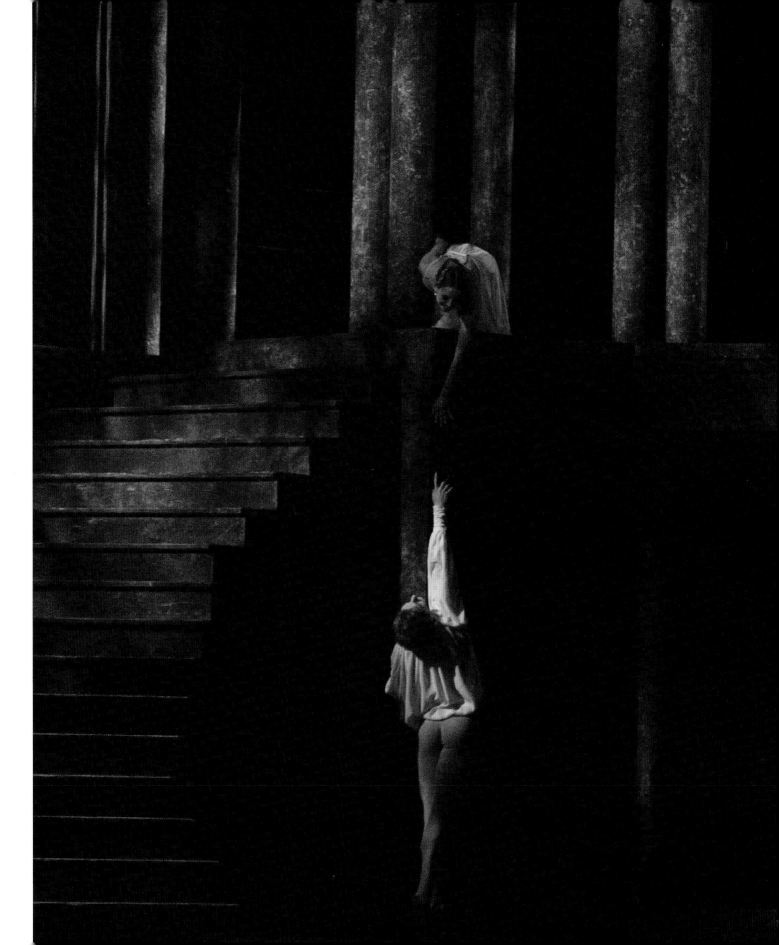

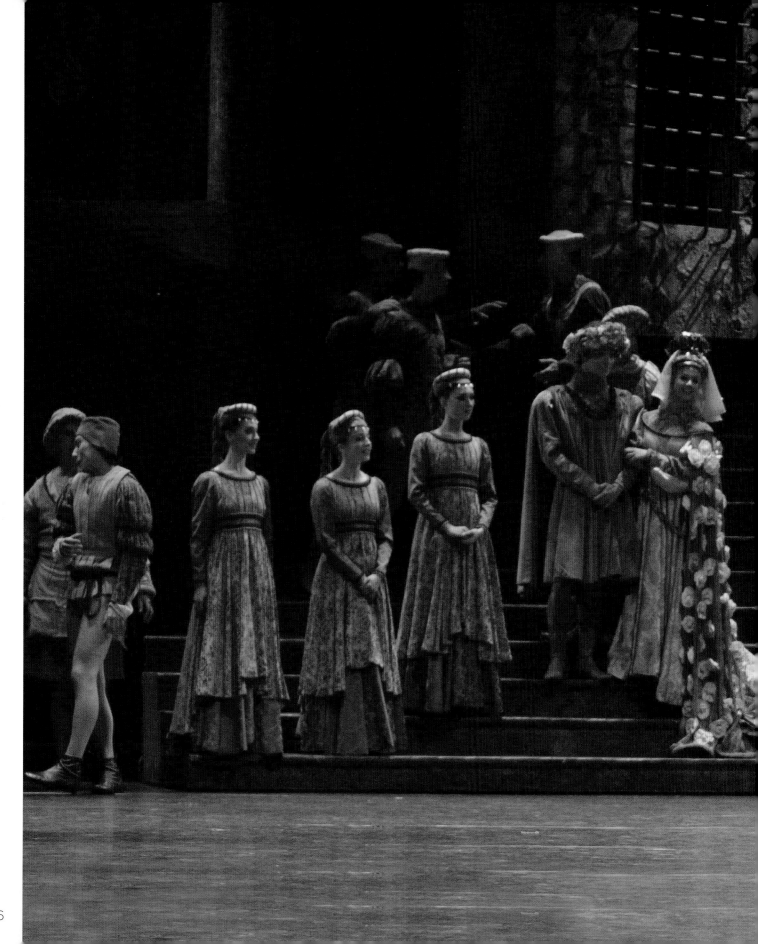

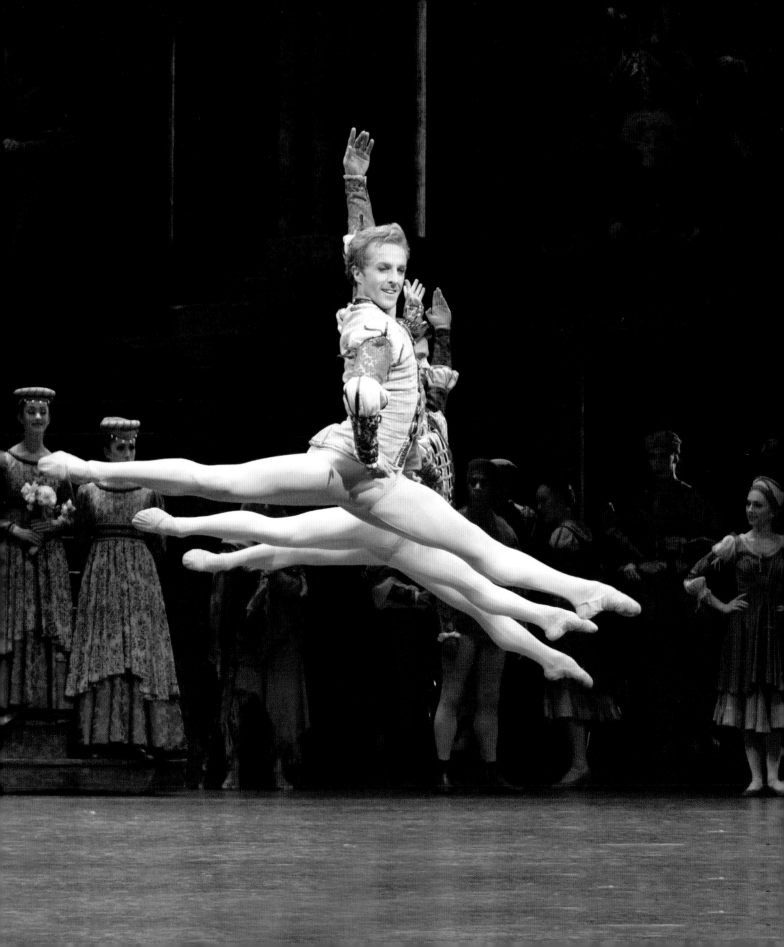

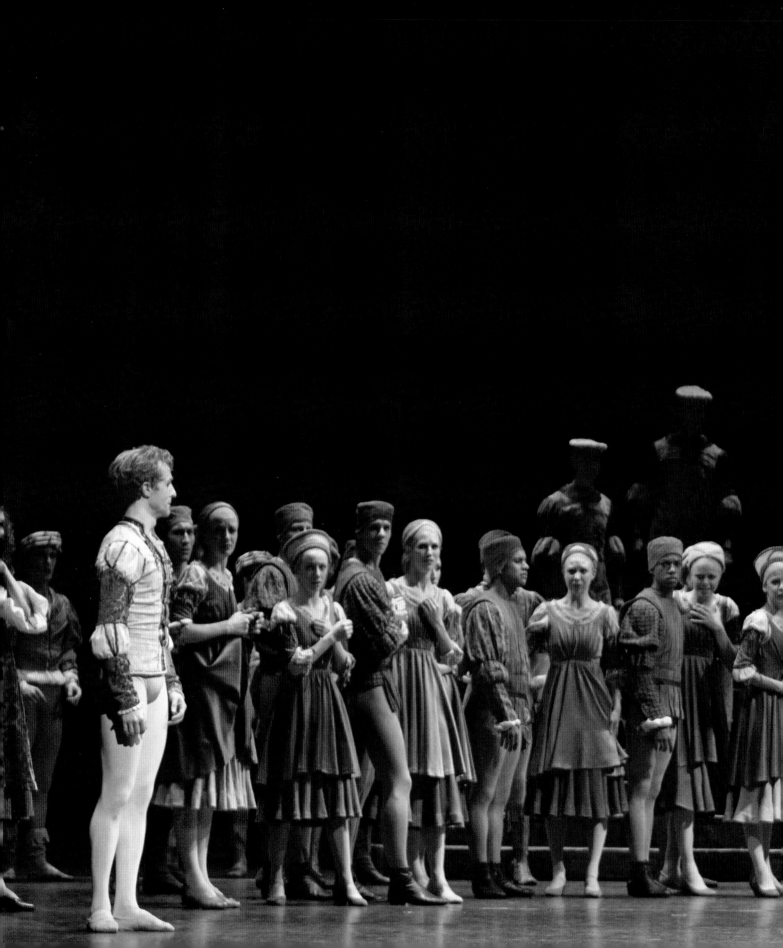

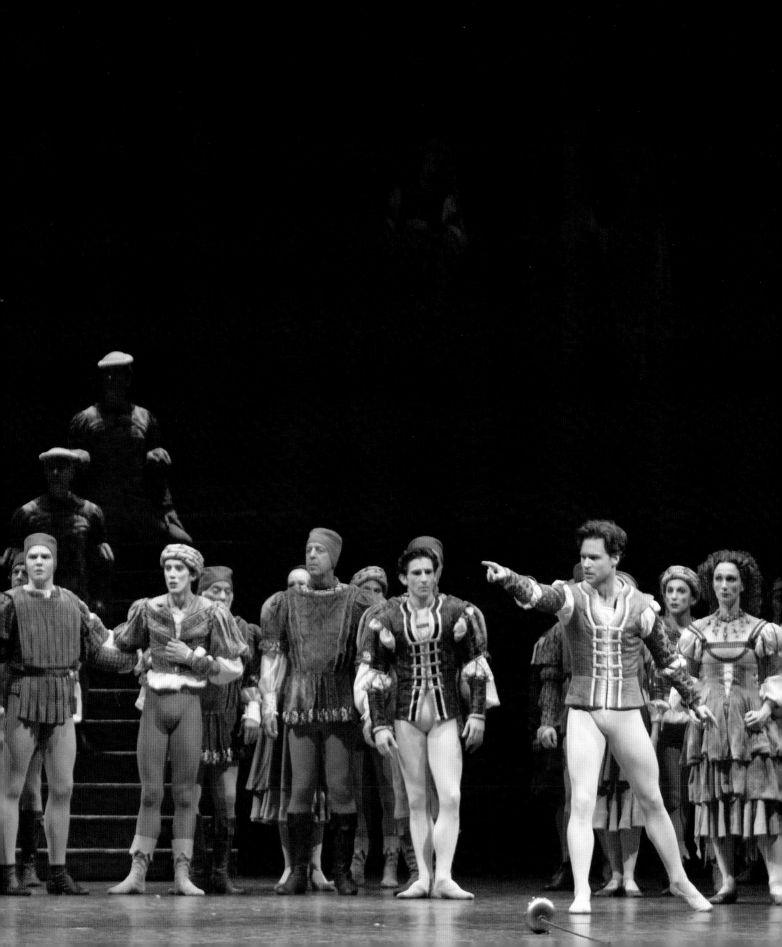

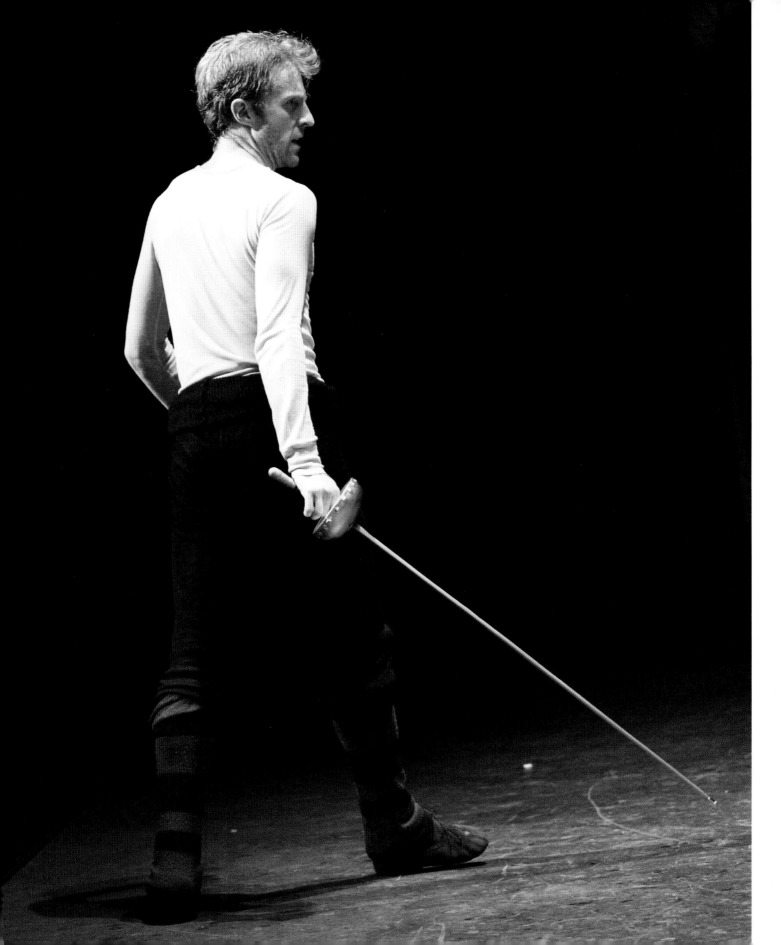

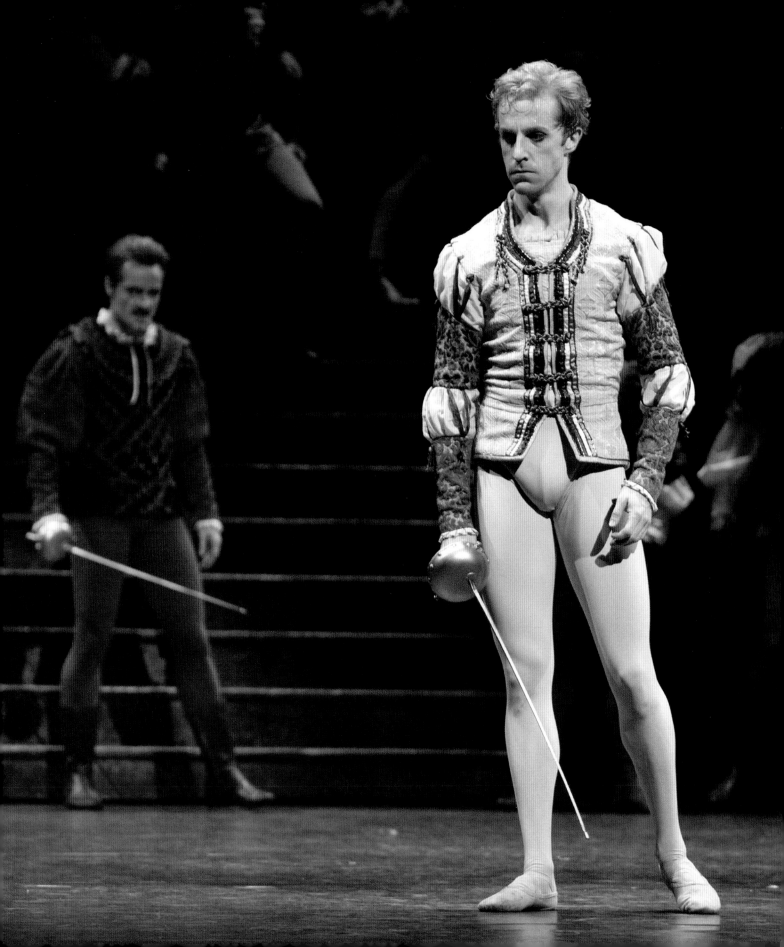

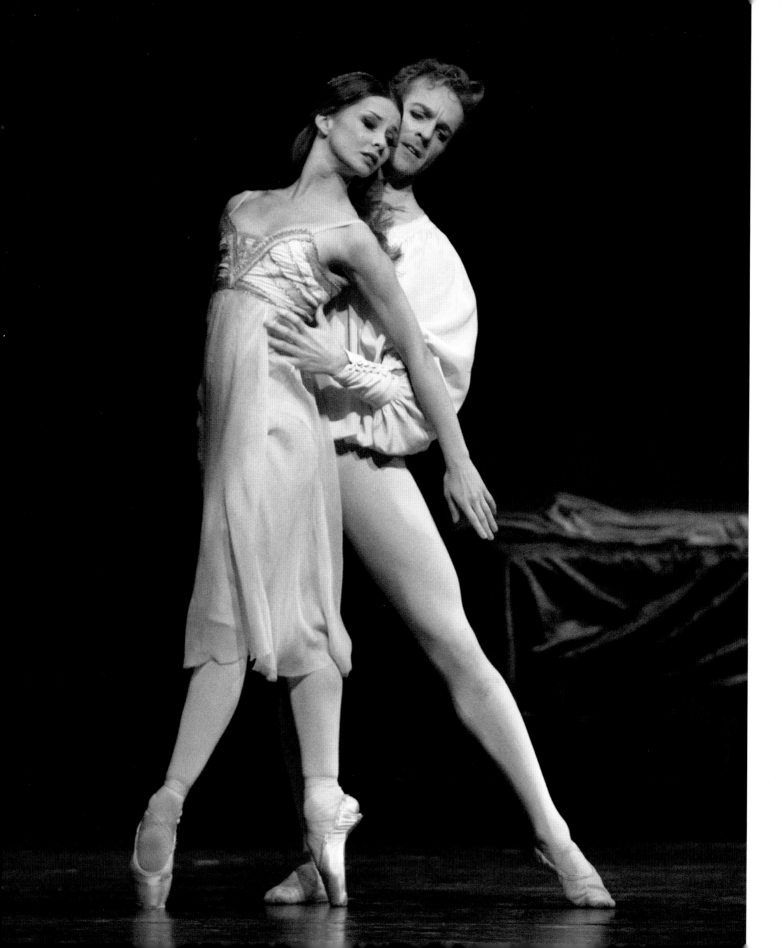

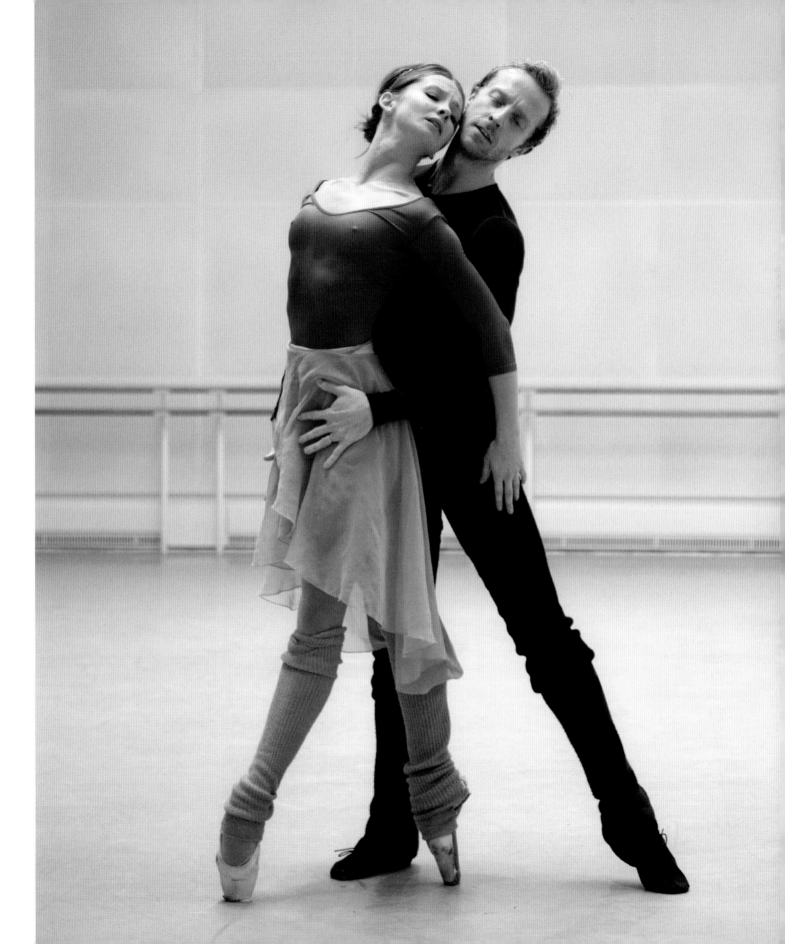

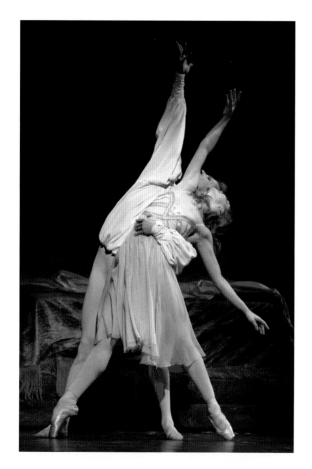

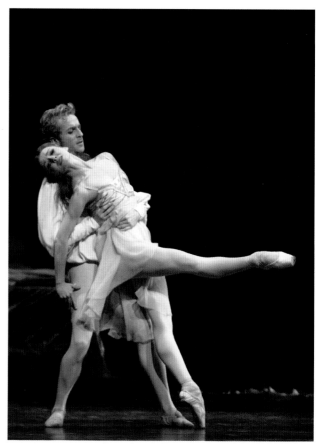

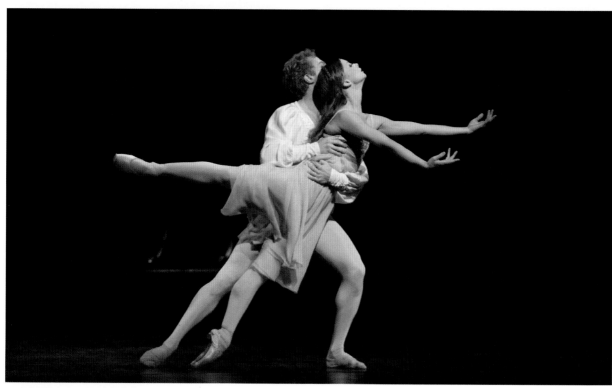

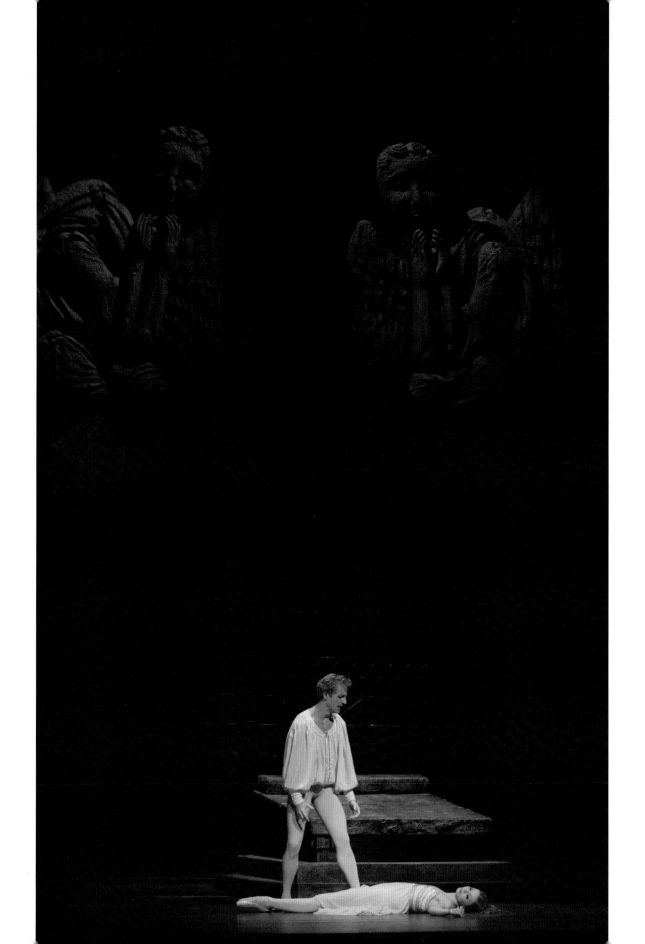

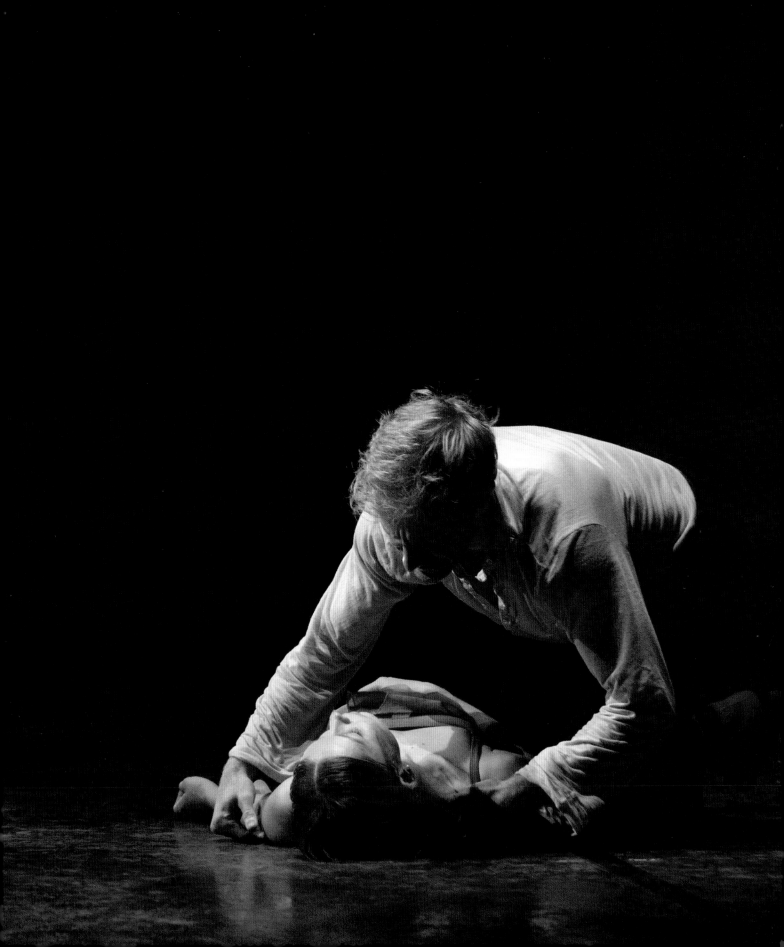

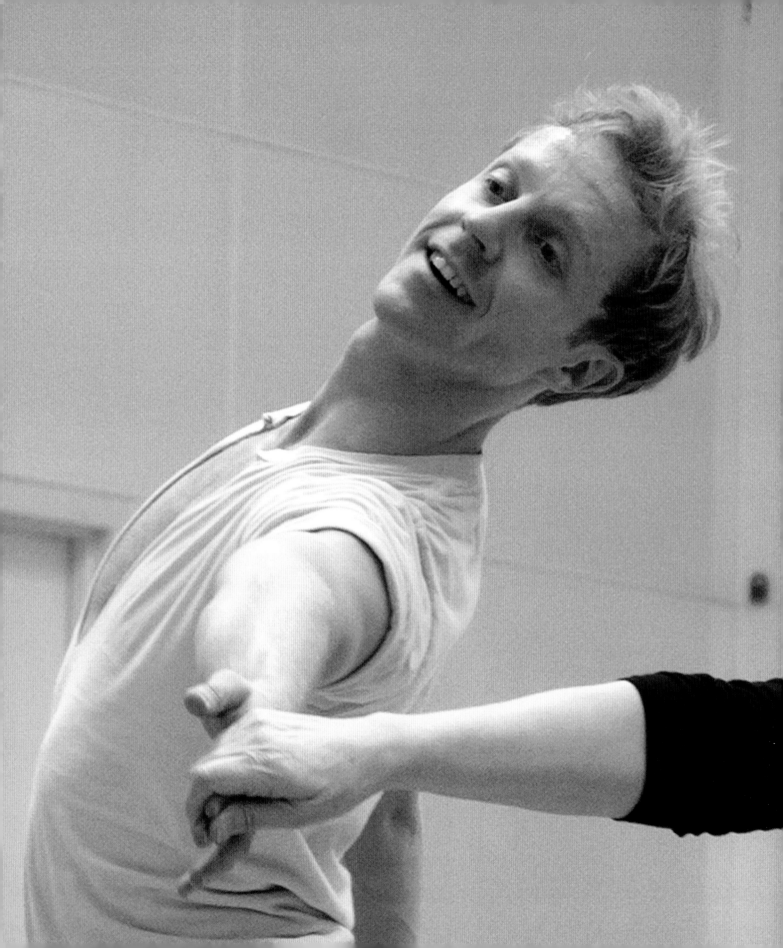

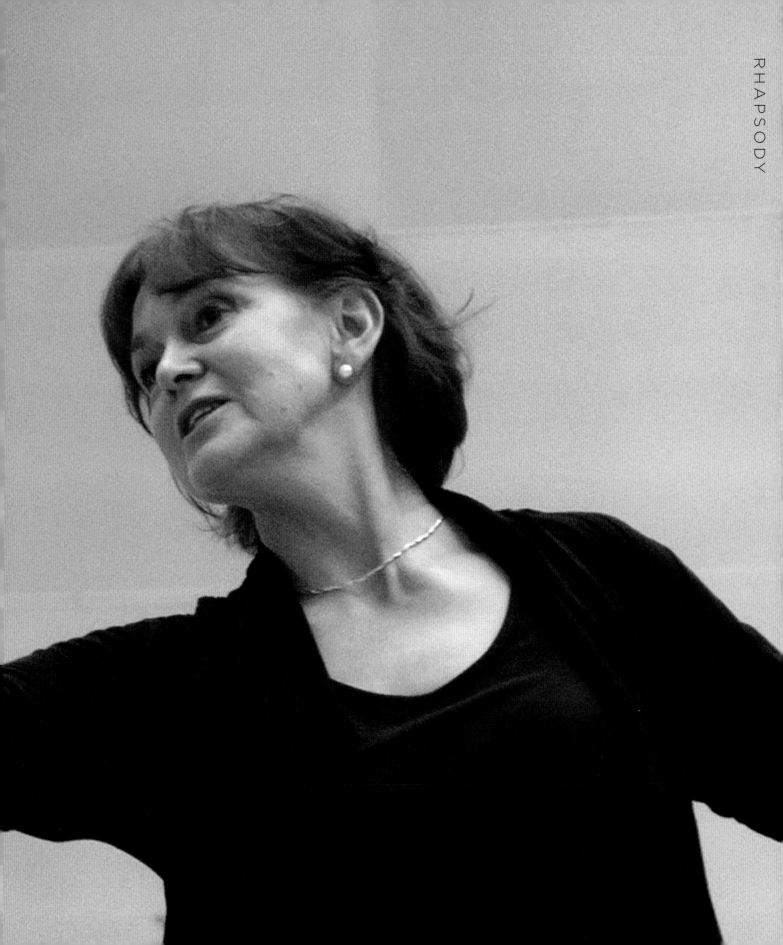

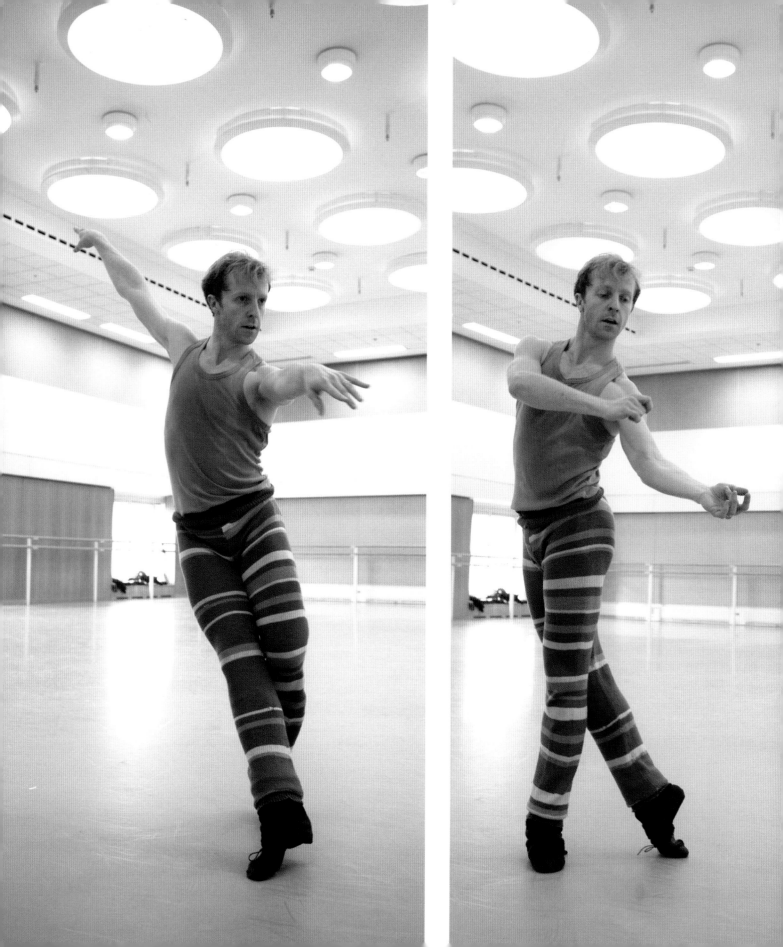

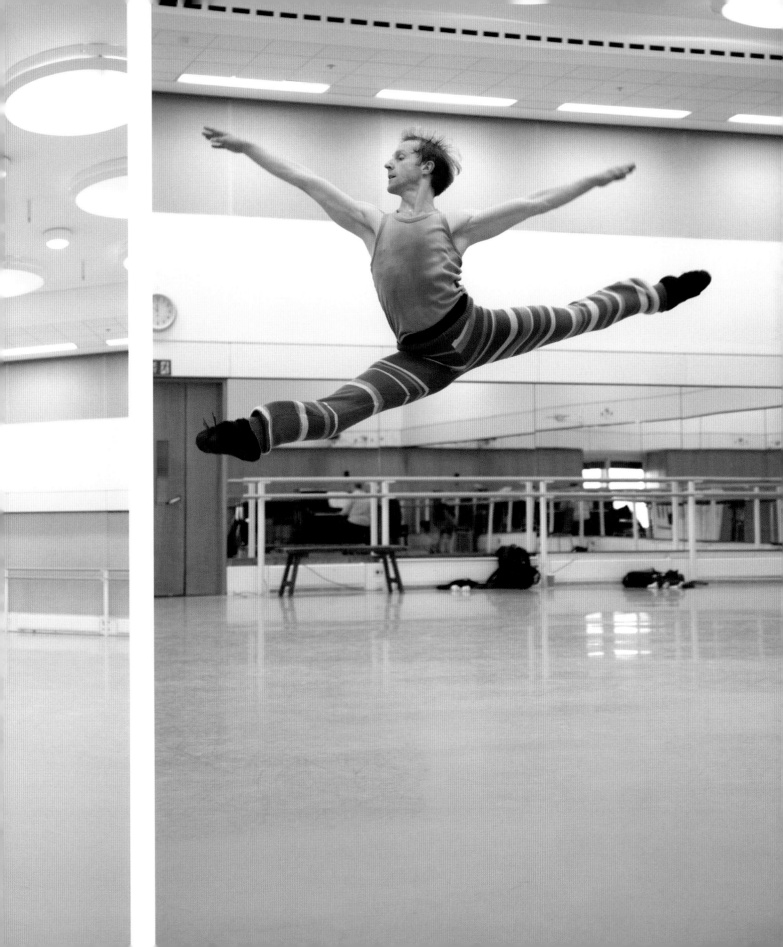

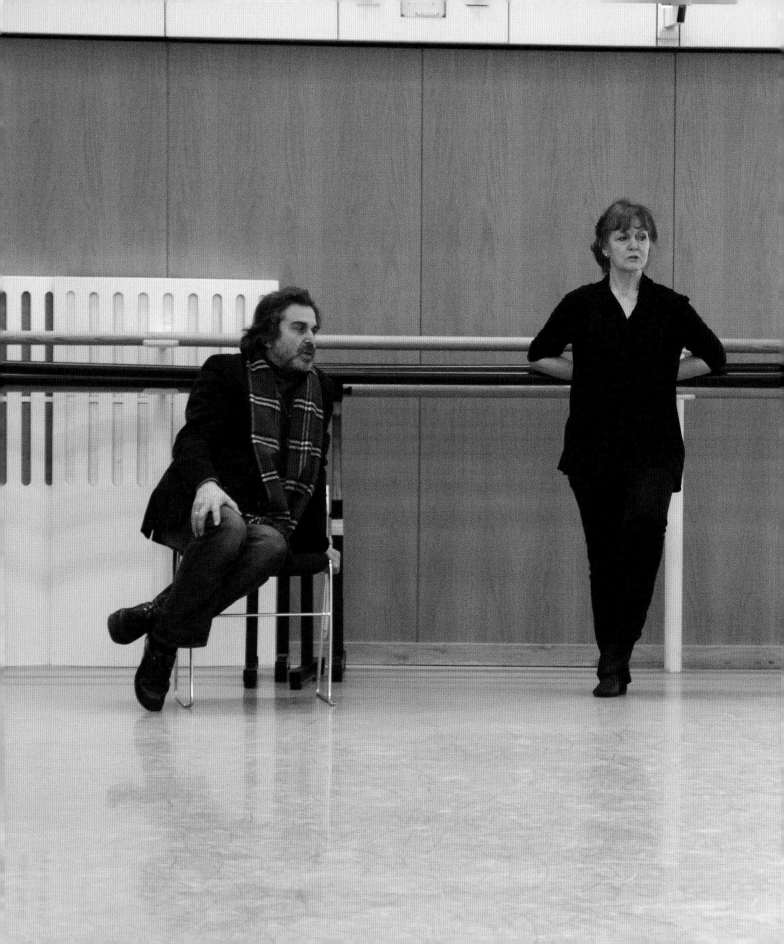

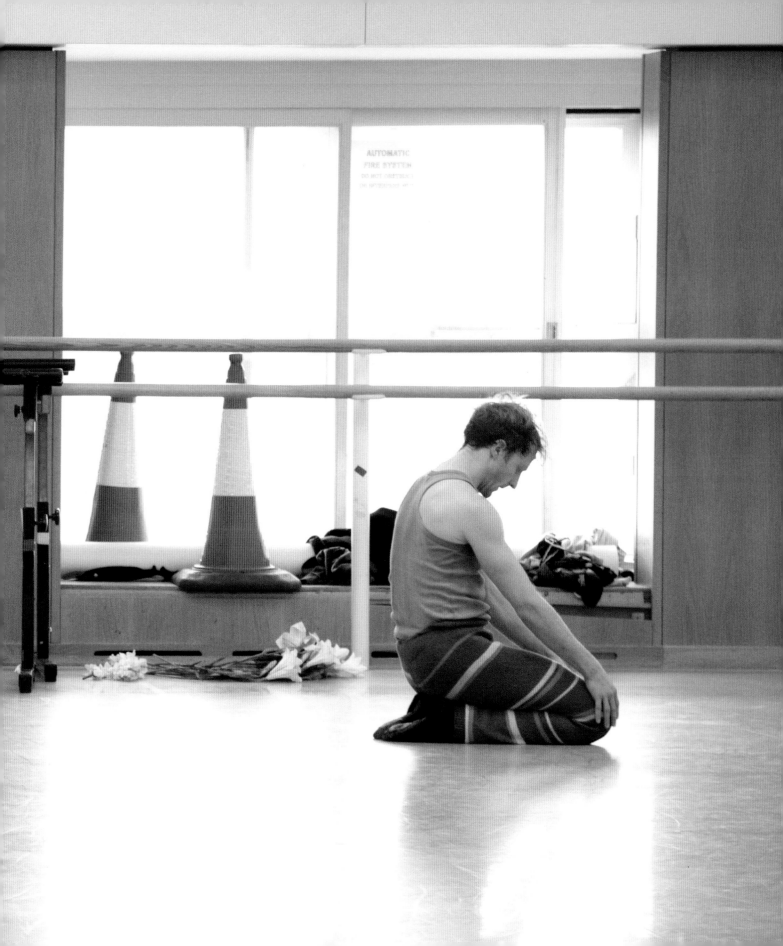

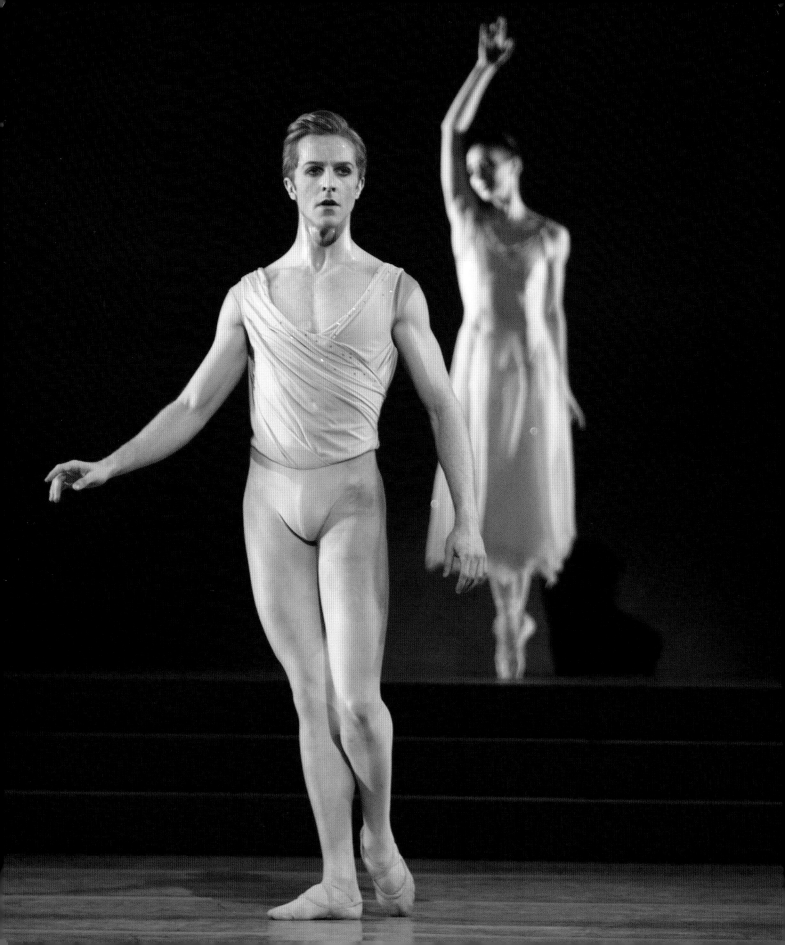

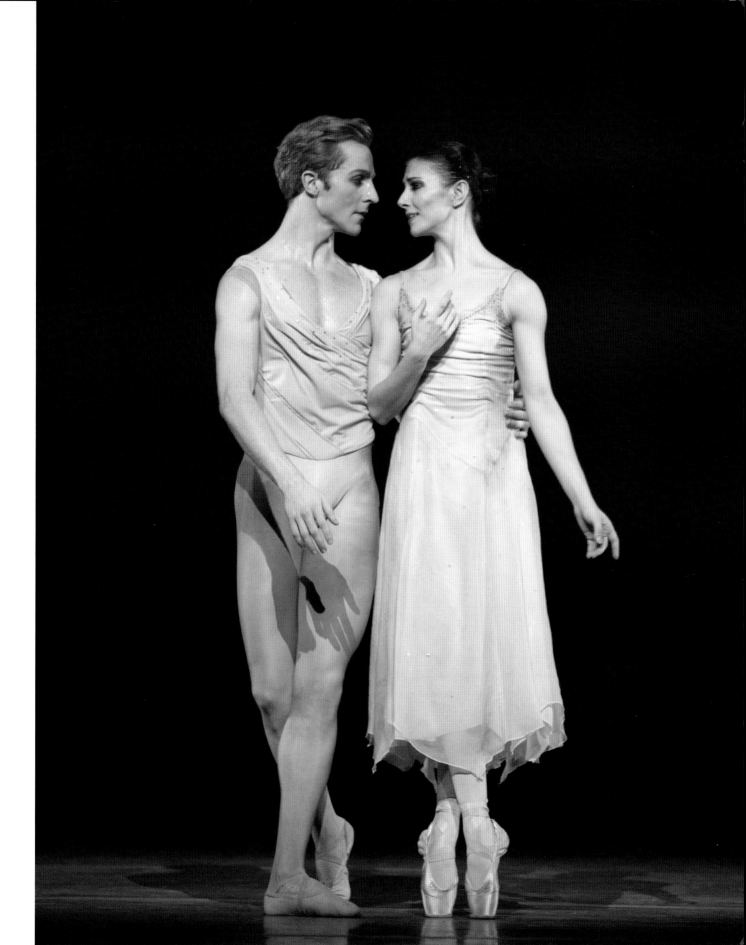

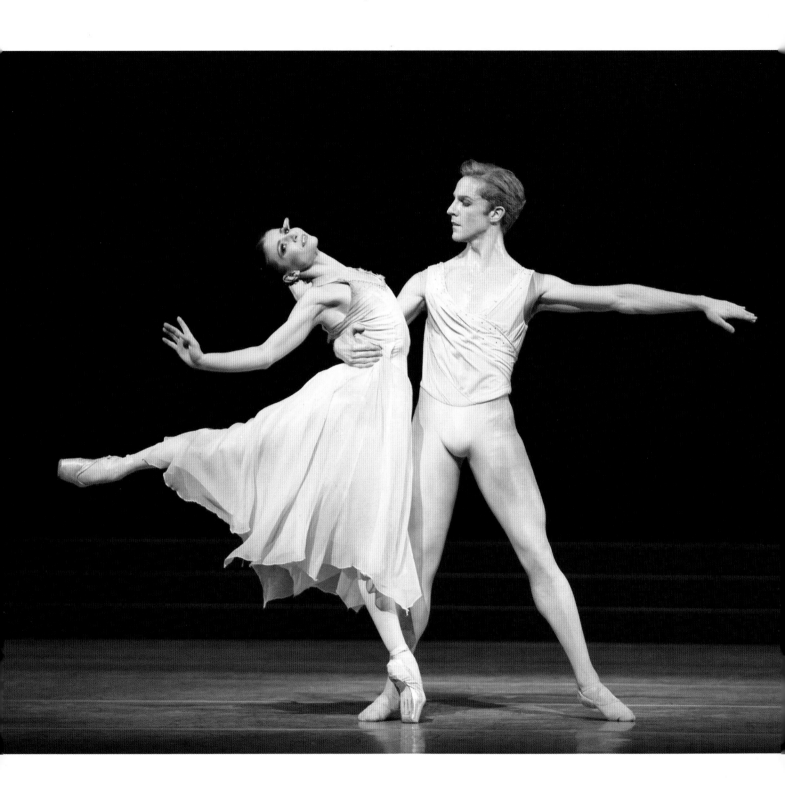

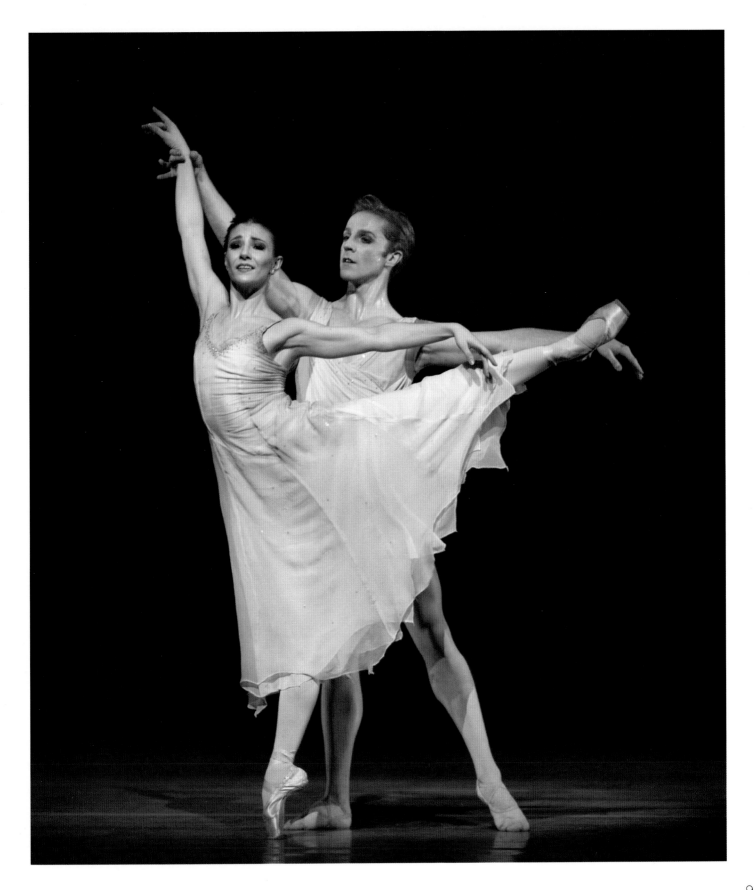

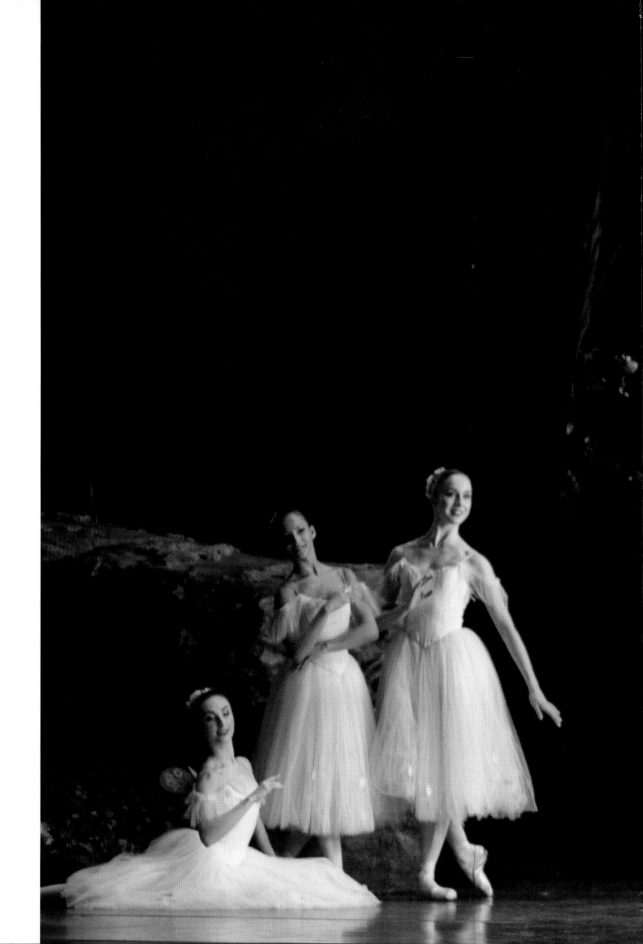

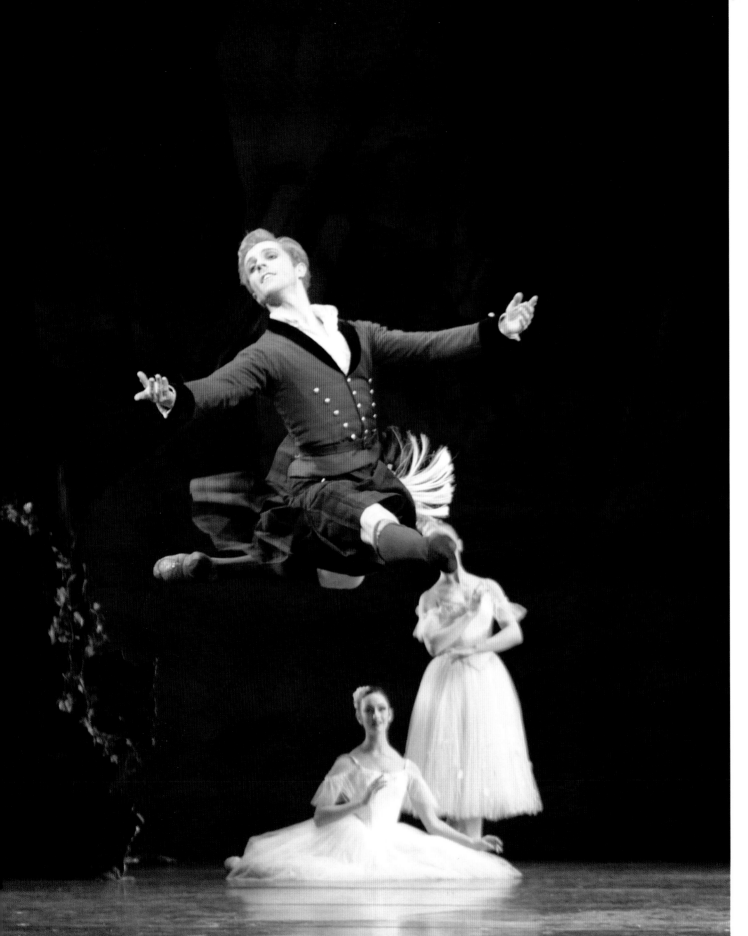

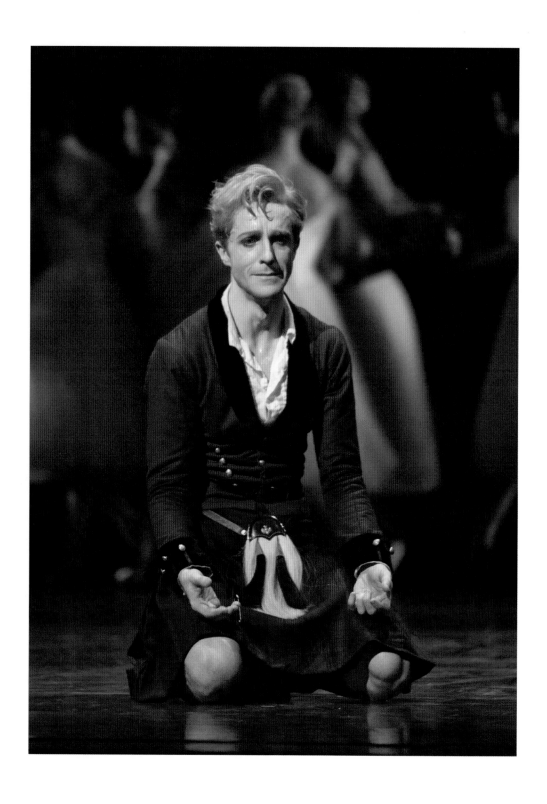

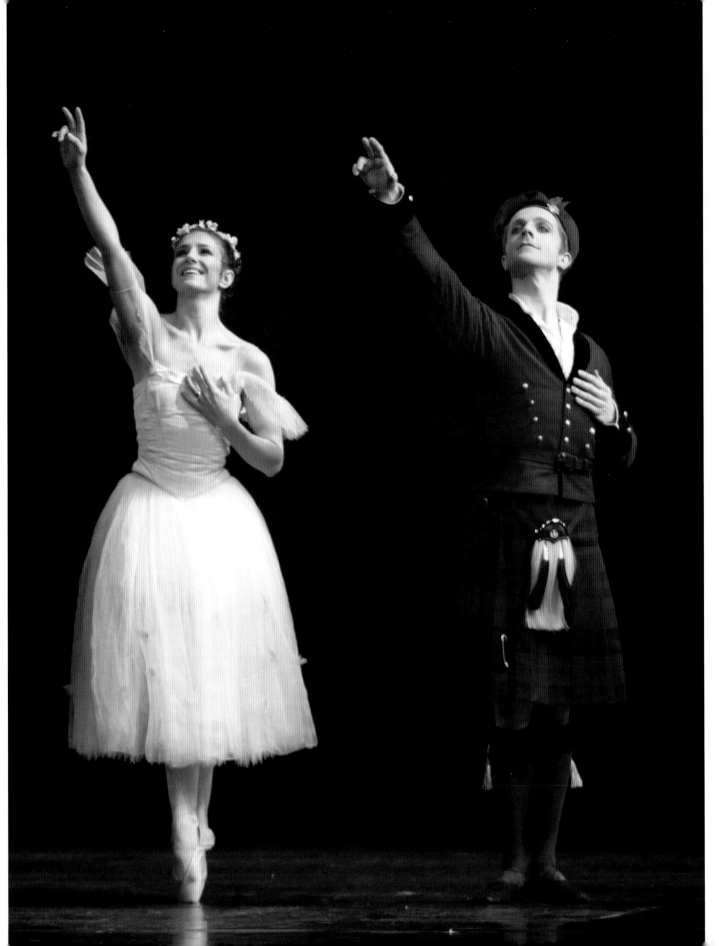

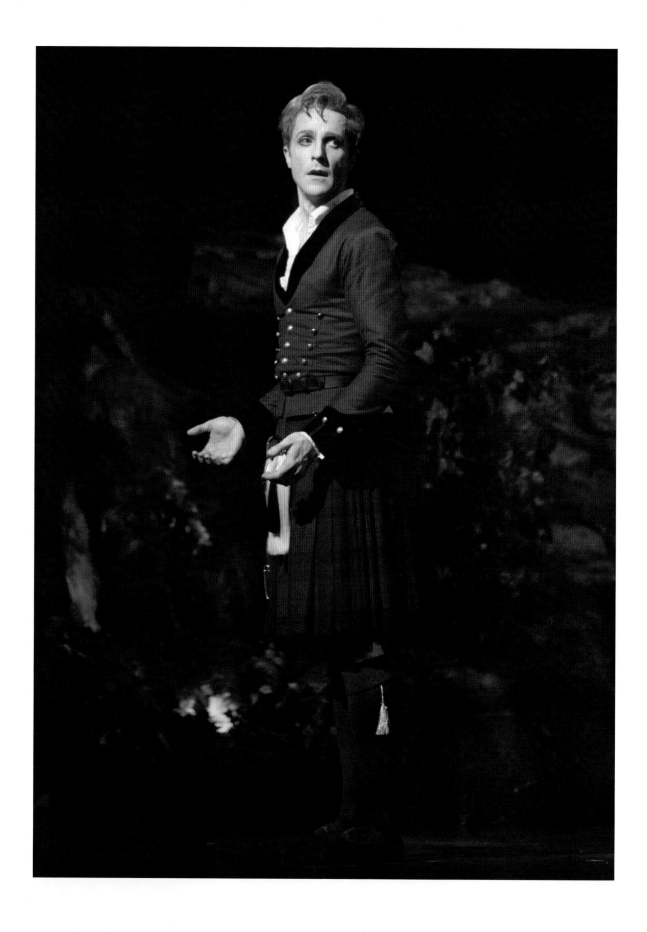

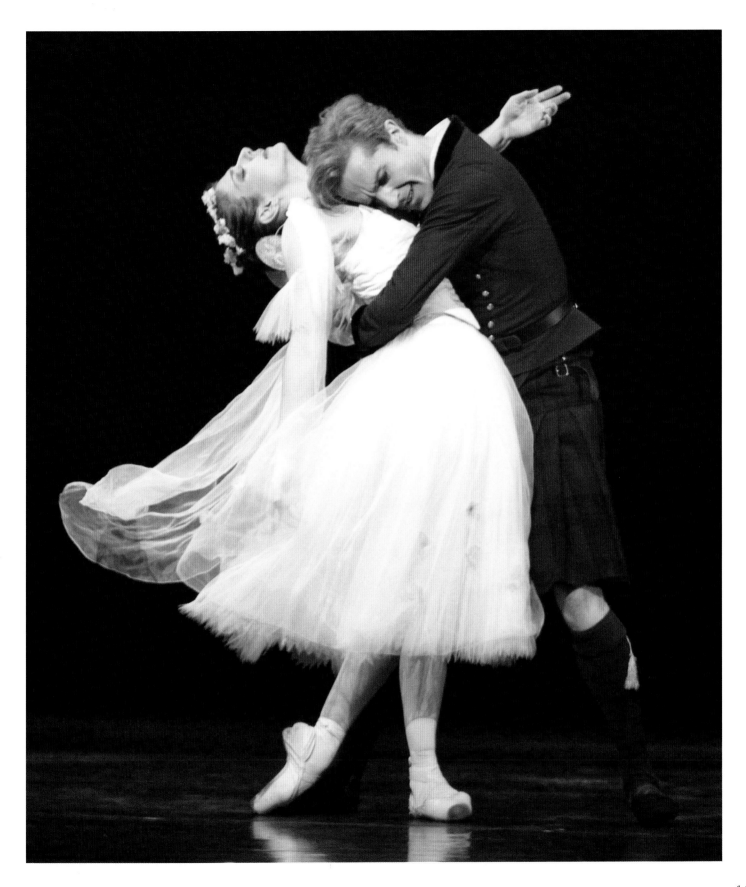

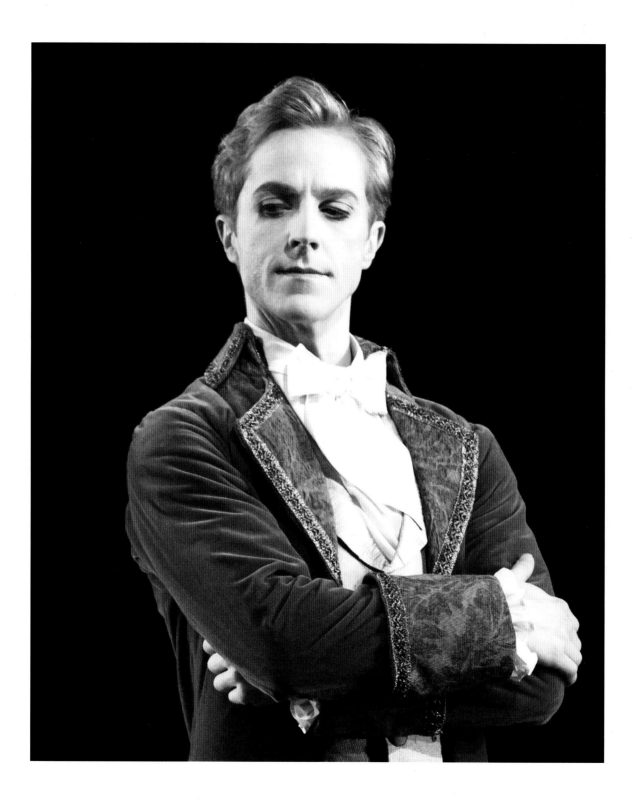

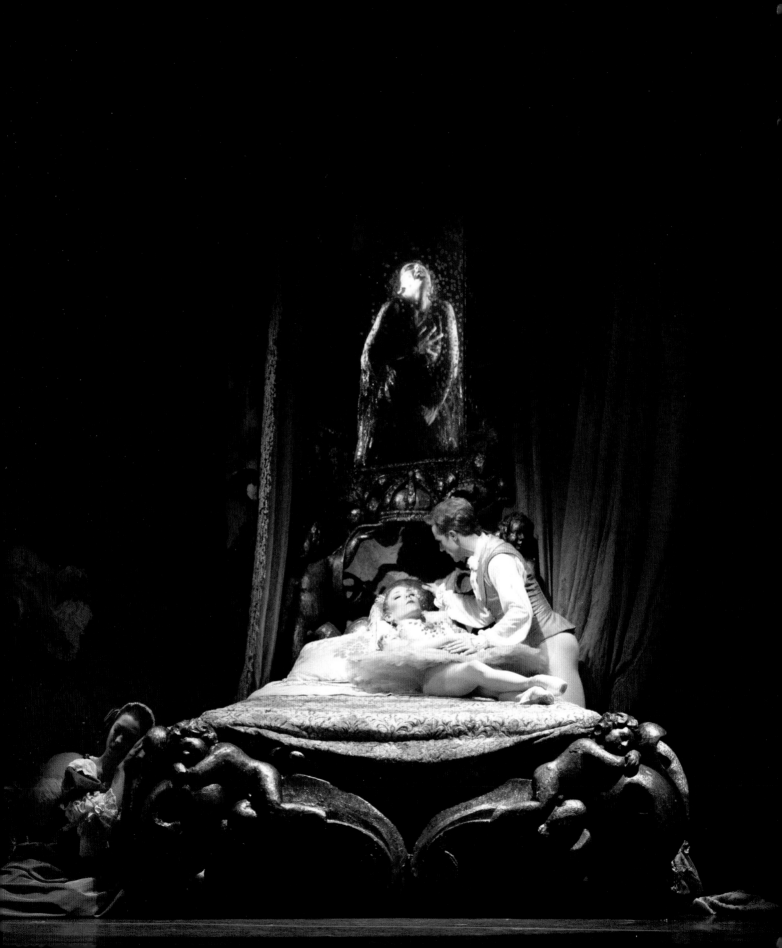

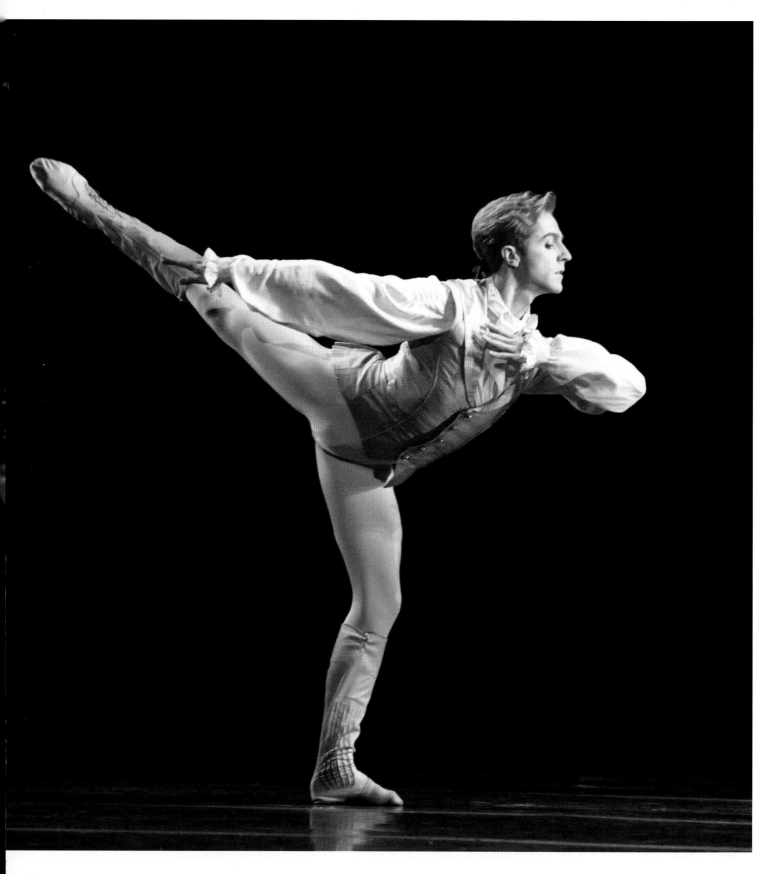

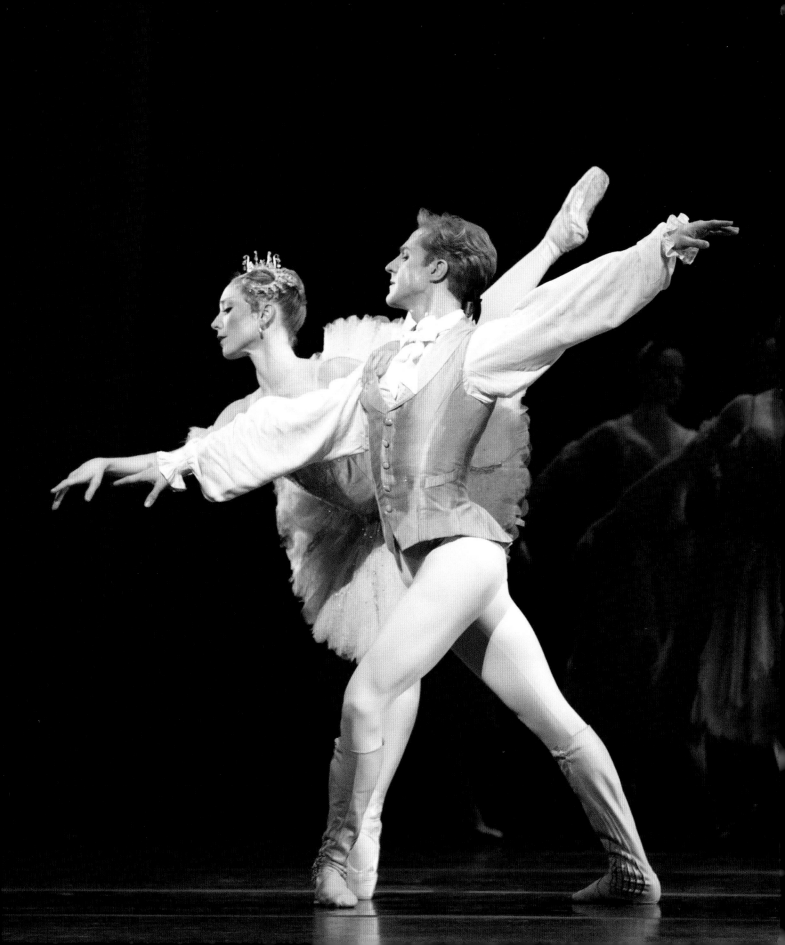

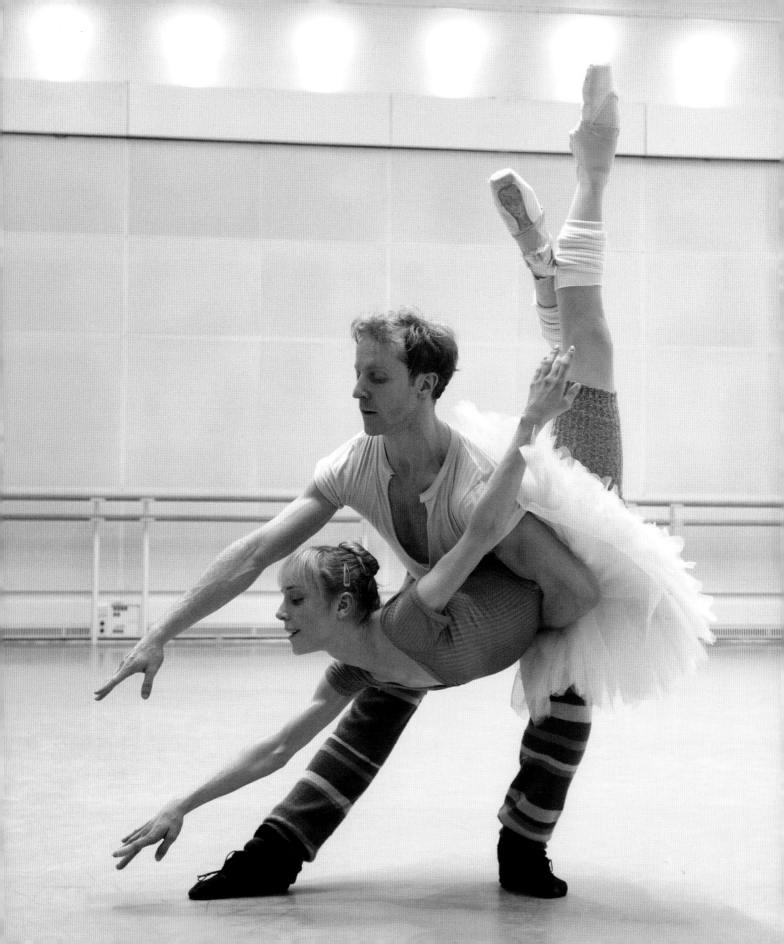

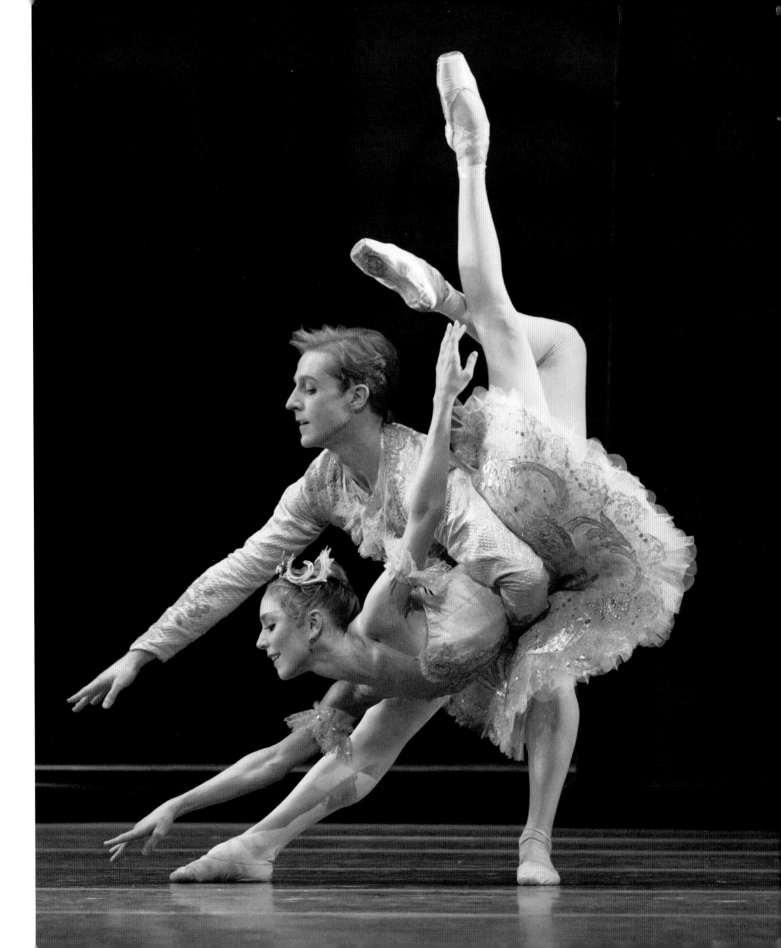

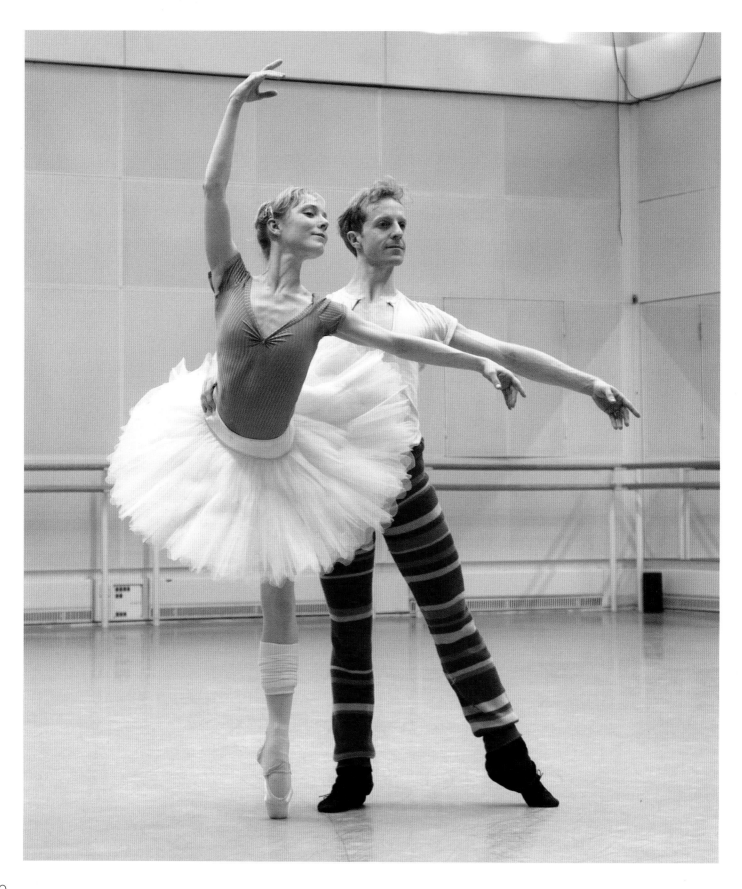

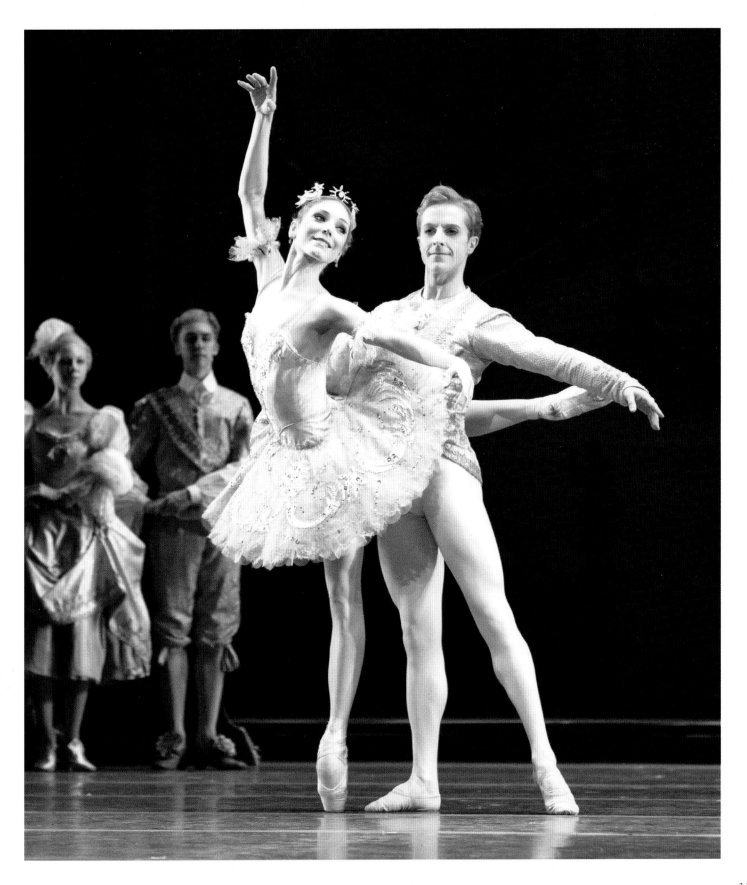

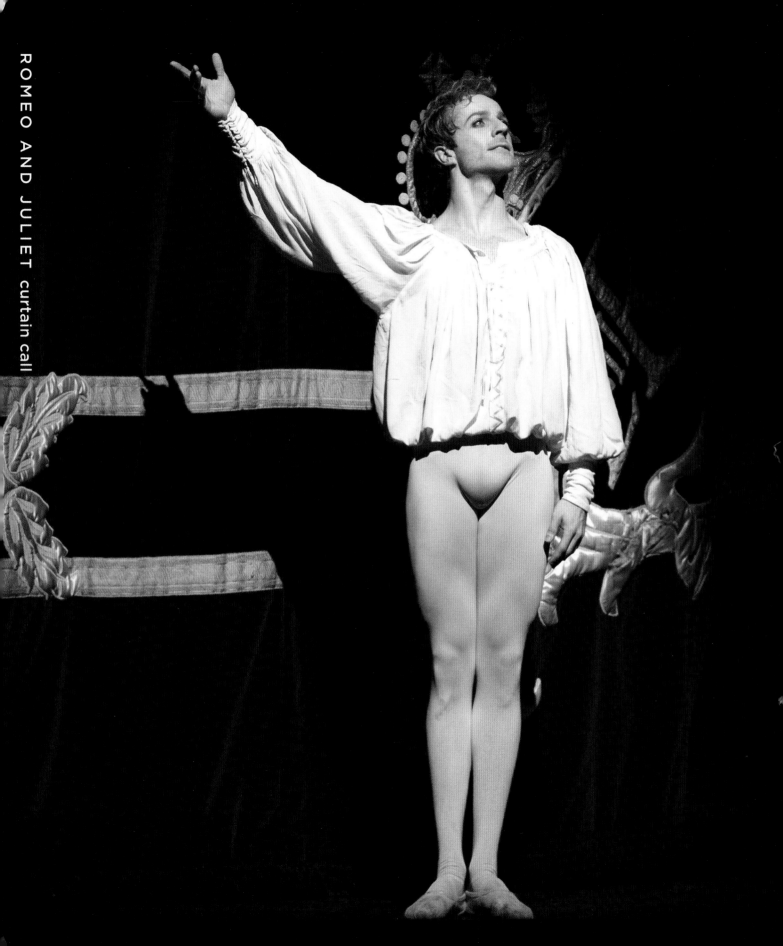

ROMEO AND JULIET curtain call